THE LITERATURE OF PHOTOGRAPHY

THE LITERATURE OF PHOTOGRAPHY

Advisory Editors:

PETER C. BUNNELL
PRINCETON UNIVERSITY

ROBERT A. SOBIESZEK
INTERNATIONAL MUSEUM OF PHOTOGRAPHY
AT GEORGE EASTMAN HOUSE

THE ELEMENTS

OF A

PICTORIAL
PHOTOGRAPH

BY

H. P. ROBINSON

ARNO PRESS
A NEW YORK TIMES COMPANY
NEW YORK ★ 1973

Reprint Edition 1973 by Arno Press Inc.

Reprinted from a copy in
 The George Eastman House Library

The Literature of Photography
ISBN for complete set: 0-405-04889-0
See last pages of this volume for titles.

Manufactured in the United States of America

———◆———

Library of Congress Cataloging in Publication Data

Robinson, Henry Peach, 1830-1891.
 The element of a pictorial photograph.

 (The Literature of photography)
 Reprint of the 1896 ed.
 1. Photography, Artistic. I. Title.
II. Series.
TR642.R59 1973 770'.1 72-9228
ISBN 0-405-04934-X

THE ELEMENTS OF A PICTORIAL PHOTOGRAPH.

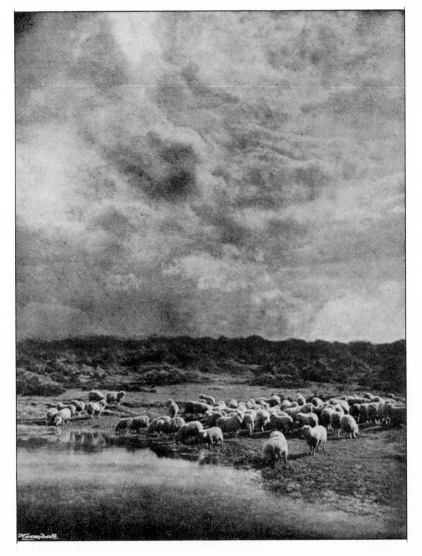

STORM CLEARING OFF.

THE ELEMENTS

OF A

PICTORIAL
PHOTOGRAPH

BY

H. P. ROBINSON

Author of
" Pictorial Effect in Photography,"
" The Studio, and what to do in it " etc.

ILLUSTRATED BY THE AUTHOR.

BRADFORD :—
PERCY LUND & CO., LTD., THE COUNTRY PRESS.

LONDON :—
MEMORIAL HALL, LUDGATE CIRCUS, E.C.

1896.

PERCY LUND AND CO., LTD.
PRINTERS AND PUBLISHERS

THE COUNTRY PRESS, BRADFORD
AND LONDON

TO MY BROTHERS OF THE

LINKED RING

WHOSE EFFORTS HAVE DONE MUCH
TOWARDS SAVING THE ART OF PHOTOGRAPHY
FROM EXTINCTION.

CONTENTS.

PREFACE.

PHOTOGRAPHY is becoming so very useful that
it is a question whether it will not in time be
forgotten that it was originally intended as a means of
representing the beautiful, and become known only as
being the humble helper in everybody's business except
its own, from that of the astronomer, who uses it to
discover unsuspected worlds, down to that of the
"brewer and baker and candlestick maker." It may be
said that there is scarcely anything our art cannot
accomplish, even to seeing things invisible to ordinary
senses and photographing the living bones of which our
frames are made. The only impossibility to the art—
if we are to believe some art critics who appear to have
had little opportunity of observation—is that it can
produce art; this little treatise contends that the camera
is only a tool in the sense that the brush is a tool, and
one capable in the hands of an artist of conveying
thought, feeling, expressing individuality, and also of
the usual attributes of art in their degree.

From the earliest times photography was intended
to produce pictorial results. The first photographers
devoted all their attention to making pictures, and there
has always been a few who have endeavoured to keep
the sacred lamp of art alight, but the adaptability
of the processes to every purpose under the sun, has
interfered greatly with its fitness for finer issues.
Another cause of decadence has been the curious fond-
ness of the public for meretricious untruthfulness, such

as mistaking smoothness and polish for beauty, and venerable wrinkles for ugliness. Still another, and perhaps the chief cause, is that there are many men who can understand an obvious fact to one who has a feeling for the sentiment of beauty. The former find that the hard nuts of science (whether they crack them or only break their own teeth) easily satisfy their aspirations, and at the same time they cannot feel much conviction about a thing they so little understand as art. The efforts, however, of the promoters of the Photographic Salon during the later years, have met with very great success in inducing photographers and the public to take a more serious view of the art.

This is not intended to be so much a serious treatise on art, as a book of hints and suggestions supplementing, but distinct from, a former volume—" Pictorial Effect in Photography." I want to help the amateur to recognise that there is much more in the art than the taking of a simple photograph, that its materials are only second in plasticity to those of the painter and draughtsman, and that if they are more difficult to manage, there are effects to which they are even more adapted than any other means of art. Much of the volume will be found useful for suggesting subjects which are possible to those means.

I should add that parts of some of the chapters have already appeared in the *Art Journal, The Photographic News, The British Journal of Photography* and *The Photographic Times* (New York).

The Elements of a Pictorial Photograph.

CHAPTER I.

INTRODUCTION.

B Y the kindness, perseverance, and research of our scientific friends, and the enterprise of those who find in our art a manufacturing interest, we are now so well supplied with all our necessary and unnecessary wants that nearly the only difficulty left in photographic manipulation seems to be in the choice of materials. If it is not quite reduced to this level it must be admitted that the mechanical parts of the art are diminished to such easy methods, that there is not much difference between the quality of the work of one photographer and another, and in the production of a picture the ordinary photographic perfection, although not to be neglected, gives very little cause for anxiety. In other methods of picture-making the attaining of this perfection of manipulation would go far towards the making of an artist; in photography it seems to have little or no influence. The cause for this " effect defective" is not far to seek. A painter has to study his art through

years of patient imitation ; if he is to be anything better than fifth-rate he gives his life to it. During his long probation he has time to absorb, and does so almost unconsciously, the principles and *spirit* of the art to which he is devoted. Not so with the present-day photographer. Much as he is among what he calls pictures, he has very little opportunity of learning anything about art, except what he looks for and finds outside his pursuit, and in the pursuit itself there are distractions which disturb the mind from that contemplative state from which only successful results may be expected.

But although the average photographer comes to a dead-lock when he gets to the end of technical excellence as generally understood, there are still left some most fascinating technical difficulties to get over of which he at present knows nothing, merely because he has not yet acquired the eyes to see the use of them. These will certainly enchant him if he ever get so far on his second journey as to be privileged to know them.

Perhaps one of the most visible truths, yet the least visible to the average amateur, and one of the most difficult to convey to his mind, is that photography in itself is not picture-making any more than writing is literature, or using weights and measures is science. When this is generally understood and accepted we shall have made a step in our progress to the distant goal.

As I am about to write on the elements of a picture I may possibly be expected to begin by defining what a picture is, but I feel strongly disposed to leave that to be understood. What is a picture ? is a bewildering question, especially when we think of some of the curiosities that bear that name in our public exhibitions. Just one remarkable example occurs to me as I write. It is the representation of a cocked-hat on a cushion in

the exhibition of the Royal Academy of 1895. It is painted by an Associate, was hung on the line, and catalogued among the pictures. We may therefore presume that we have the sanction of the highest authority in art in this country, for calling a painting of a cocked-hat, if it is by an Associate, a picture. But this does not help us much. Even a photographer would have a higher ideal of what a picture should be than this. A representation of a cocked-hat in any material would not find its way past the committee of the Salon.

As with many other words connected with art— especially the word " art " itself—many definitions may be given to the word " picture," and illustrations found, from Egyptian or Aztec picture-writing down to the last surprise by which the modern jocular charlatan in art tests the credulity of those who know no art, and yet feel it is " the thing " to admire all the more when it is impossible to understand.

Even the dictionaries are in difficulties over the word, and give as a definition this totally inadequate solution, " A likeness drawn with colours," and as an illustration of the use of the word " The child is the *picture* of his father." I need scarcely add that this has nothing to do with the picture-making with which we are here concerned.

A picture, if we must have a definition—our sort of picture—is a flat surface calculated to give pleasure to the beholder by the skilful way in which the intention of the producer is expressed by pictorial means, consisting of lines, lights, shades, masses, and preferably, but not necessarily, colours. This is the material part of the picture and is held by some, a dwindling minority, to be all sufficient. Beyond, and as I think necessary to the complete picture, is poetry, sentiment, story, the

literary part of a picture, which painters without imagination have attempted to banish, not without some success, but the fashion they tried to set up has fortunately proved transient. There must be something more yet. If it is to be really true to definition, and our sort of picture, it must be produced in the materials of our art.

Fashion, perhaps for the first time in the world's history, has been meddling with art, or the fringe of art, during the last quarter of the century. In former times painters would study under a master, or in schools, until they felt their wings sprout, when they, if there was any good in them, became original—with a flavour of their master as was natural—as their own originality dictated, but some years ago the young painter revolted, unfortunately before he had really become a painter. He did not want teaching, or would be his own master. He would have none of the old learning, the accumulated knowledge of centuries was nothing to him. Composition was a trammel, finish a delusion, story, mere literature. Genius must express itself with a stroke of the brush. This was good for his individuality, but it was individuality without backbone. It never struck him that he had not learned to paint and that genius was not an everyday commodity. Then he played his best card, he made himself and, curiously enough his work, a fashion, and for a time had a singular run of success. The more serious, however, soon found that the art on which their present success was based was not solid ; that art, although undoubtedly indebted to the revolt, does not consist entirely of values and vapours and effects that cost no trouble, and returned to art as it was, and is, and ever will be—for true art is eternal—while the less competent have to become more extravagant than ever to attract any attention.

I have written thus far hoping to show that although there may be occasional attempts at variation, art remains pretty constant to what has been taught—I had almost said from the beginning. It is very gratifying to me to find that even some writers on photographic art, who up to very recently have seen nothing that was not contemptible in such old-fashioned stuff as composition, now write of lines and light and shade and masses, and even lay down rules for the guidance of the student, very properly protesting at the same time that these rules must be regarded as guides only and not as laws, as has always been done by all good writers on the subject. All arts must have methods but they need not be made too evident. The writer of books does not find it necessary to be always repeating his etymology, syntax, and prosody, but he must write grammatically or he will offend his readers. So with the photographer; if he does not show that there is a man behind the machine *with rules*—his own if he is strong enough, or the best he can get if he has none of his own,—his result will be a machine-made article, and not an individual impression as every work of art should be.

The revolt in art to which I have alluded, now dying out, has left some good behind it. It has extended to photography with excellent results. The excessive literalism of photography wanted correcting. This it has done, and our art, rescued from the tyranny of the lens, has more freedom to express the mind of the artist, as well as the hand of the chemist and the optician. And while true art is as much indebted to knowledge accumulated in the past as ever, and cannot do well without it, the energetic endeavour of late years to sever all connection with former traditions, although futile, has had its uses. It has created more liberty in art, and attracted more attention to those things which

were falling into neglect ; it also showed that if there is such a faculty as innate feeling or instinct for art, which I don't deny, it was wrong to rely on its own uneducated power.

Let us always seek fresh light, but not be too eager to leave tho old paths until we know where new ways may lead.

In the following chapters I shall have to go over some old ground, but I hope to enforce old truths with new illustrations, and perhaps add some new truths in the old style.

CHAPTER II.

IMITATION.

THE simple elements of a picture are few. In these chapters we will endeavour to avoid all intricacies, subtleties and super-refinements, so dear to the writer of treatises on Art and puzzling to the student; our aim shall be breadth, not detail.

All art is based more or less on selected nature, but the moment the copy becomes so like nature as to become deceptive, it may be art of a kind, but not fine art. For instance, a perfect photograph in colours from nature, if it had no other qualities would not be art. Nature to became art must be filtered through the brain and fingers of the artist. Shallow thinkers seize upon this admitted fact as proof that photography cannot be a fine art, but as long as there are photographs produced that could only be made by their producers, so long will they be the work of the individual brain and fingers of the artist, and not of a machine.

A picture is a conventional representation of nature. It should be true to nature, but if it is to be a work of art it must not represent nature as faithfully as seen in a mirror. That art is not a mirror-like imitation of nature is admitted by all artists, whether they belong to the old school that has traditions they respect, or any of the numerous new sects that seem to get further from nature the more eccentric they become. But there is a tendency in all things to find a cure by stepping over the edge of the sublime. Anyway, the general opinion is that to become art the representation of nature must be more or less conventional, although we may not all

B

believe that the further we get from nature, the nearer we are to art. The orthodox painter has his laws and rules deduced from the practice of ages, and the impressionist has equally strict, if not more stringent laws, which he has made even unto himself, which place his productions among the most conventional efforts of pictorial art ever produced.

There is still a great deal written of the " Stick to nature, my boy," order. This is a survival from the time when it was much more difficult to represent the facts of nature than it is now. Before the discovery of photography there was not much danger of getting too close to nature in any art; but photography soon showed that it was possible to make a picture which more nearly represented the facts of nature than anything that had ever been dreamed of, and yet having in it no art at all. The minute imitation seen for the first time in the early photographs afforded us agreeable surprise, creating pleasure in the mind; but it was a similar pleasure to that we derive from seeing a clever juggler, rather than that we obtain from viewing a work of art, to which may be added the delight and curiosity of seeing a new thing, and admiration for the scientific knowledge that could produce such a wonder. Times have changed. Curiosity in ordinary photographs is no longer excited, and the necessity for scientific knowledge is reduced to a nothing, or, at any rate, is much attenuated.

From a highly and skilfully finished painting—one that is really a minute copy of the facts of nature—although it may not have any pretence to poetry or sentiment, we get another kind of satisfaction. We admire the dexterity of the artist's hand and the power he shows of seeing vividly both form and colour. But we must know that it is a deception before we can enjoy

it ; it must be a gentle surprise, and not a delusion. The deception must not amount to what is vulgarly, but expressively, called a "sell." Deception offends us, or suits only the lower or uneducated nature. A wax-work figure does not excite such pleasurable or elevated emotions as a marble statue; yet we know that, in the hands of a clever modeller, a wax figure can be made so nearly to represent nature as to be absolutely deceptive. I have run against one myself and begged its pardon.

Now, although the marble may imitate Nature, there is no attempt at deception. As Mr. Ruskin puts it, " A marble figure does not look like what it is not; it looks like marble and like the form of a man, but then it *is* marble and it is the form of a man. It does not look like a man, which it is not, but like the form of a man, which it is."

It may be said that the pre-Raphaelites of between 1848 and 1860 created wonders of art with more minute imitation than had ever been known in paint. So they did. But one of the sources of delight was in the skill and patience shown in such minute finish, and the success lay in the fortunate chance that the experiment was undertaken by enthusiastic young men of genius, and the novelty, intensity and power of their pathetic subjects. In short, the thing said was eminently worth saying, and the saying was said as it had not been said since the time of the early German and Flemish masters between 400 and 500 years ago. Astonishment was one of the causes of admiration, but surprise was accompanied by other qualities, such as splendid colour and expression. The combination of the power of expression, colour, and minute fidelity to nature in these pictures was so extraordinary that no suppression or subordination was required to lead the eye to the principal parts. There

are superfine art critics now who will go into raptures
over a few scratched lines on a copper plate who would
not allow that the art of which I have been writing was
art at all. But, in my humble opinion, there has not
been such great art produced this century as Millais'
Ophelia and *Huguenot*, and Hunt's *Claudio and Isabella*. I
still have the pleasure of occasionally sitting in the room
in which the *Ophelia* hangs, and am never weary of its
wondrous beauty.

It may be claimed that the early photography sug-
gested this excessive study of nature. It probably did ;
but it was only a suggestion. The best men worked
entirely from nature ; their imitators took to copying
photographs, and then came degeneration, for copying
is a different thing from imitation aided by genius, pre-
Raphaelite paintings' only merit was to become very like
nature, and " very like nature " has never been enough
in itself to make an endurable picture, whether in paint
or any other medium.

It is true that nature must be imitated, but it is of
little use if the man who turns the handle of the box of
music has not the singing voice.

One reason why imitation is contemptible, as Ruskin
calls it, is that it is easy. He says : " To the ignorant,
imitation, indeed, seems difficult, and its success praise-
worthy; but even they can by no possibility see more
in the artist than they do in a juggler, who arrives at a
strange end by means with which they are unacquainted,
and juggling implies more ingenuity in the artist than a
power of deceptive imitation." Now, photography gives
incomparably the greatest amount of power of minute
imitation or copying with most ridiculous ease, and it
has lost the power of surprising us with its fidelity, for
the detail of a photograph is one of the most ordinary
objects of civilised life. Neither does the skill with

which the minute finish is attained now affect us; we recognise that the skill necessary to produce the cleanest, minutest, and most sparkling work is as minute as the work itself, and not to be considered in the result. That there is a skill and a use for technics far beyond those usually employed is also beginning to be recognised. It is not a technic that can be logged down in a text-book, but to use this technic necessitates a knowledge of art, the elements of which only can be taught, and it is this "world beyond" that must attract the photographer if he wishes to attain to, or remain on, the higher level. In future the photographer must no longer trust to the last moment for sufficient time to allow him to produce his masterpiece for exhibition. He must now take time to work up a favourite subject, or realise a beloved idea, and tax his powers to the utmost, spending as much time upon his effort as he feels is necessary to bring it as near perfection as his energies will allow; and, above all, if the result does not come within measurable distance of his ideal, to destroy it remorselessly. I am sorry to have to add that, the more progress he makes, the further he sees, the more of his work will he destroy, to which fact—without claiming to see further than others—I am a painful witness. I happen to be the possessor of the mortal fragments of a large, and, I thought for a time, important photograph, on which I had worked for months, and only destroyed after it was framed and ready for the last Salon.

Now we come to the imitation of the works of one artist by another.

It is a moot point how far one artist may imitate— I don't mean exactly copy—another, and yet feel that he continues honest, morally and legally, and, supposing he decides to sail near the wind legally, how near he may

go, and still be able to look a brother artist in the face without blushing.

This question of imitation is a delicate and difficult problem. In a learner it may be a merit, in a master a crime. But how are we to estimate it when an artist imitates himself, and does it always? We can only say he becomes a manufacturer. Yet again, we should be sorry if some artists forsook their own delightful style.

Apart from its morality, the value of imitative work depends a good deal on circumstances. If it is the work of a very young man, it may be, educationally, praise-worthy, and may be tentatively called promising, especially if he shows his taste by selecting a good master for imitation, or even a good school; his copying has not become sinful yet, and he has time to become more original. It is the constant imitation by mature artists that should be one of the unforgivable sins. This is especially true in photography, in which art the mechanical execution of an imitation is a negligeable quantity. It is the original thought, plan, treatment, style that constitutes the merit.

Imitative work is interesting, to a certain extent, to the producer—he learns something by producing it— but is worth little to the world ; it is but as an oleograph to a painting. Do we thank the man who bores us by feebling whistling over a sonata he has just heard played by Paderewski? There is even merit in imitation when properly used. It is better for the student if he is *not* troubled with too much originality during his noviciate ; it distracts his thoughts from the work suitable for his studentship; but he should not show his imitations as his own original work. This, I am afraid, is constantly done in photography.

It is not meant that ideas, hints and suggestions should not be picked up from the works of others.

Imitation, if it is imitation, of this kind is allowable. As the poet says,—

> " Who solely on his own resources draws
> Lives like a bear by sucking his own paws "

On the other hand, it is a mistake to go too far; it is well to weigh the question carefully. How much may be stolen? As Peter Pindar said of Gainsborough when he copied Snyder's dogs into one of his own pictures :—

> " I do not blame thy borrowing a hint;
> For, to be plain, there's nothing in't—
> The man who scorn's to do it is a log;
> An eye, an ear, a tail, a nose,
> Were modesty, one might suppose ;
> But, zounds! thou must not smuggle the whole dog."

There is yet one other kind of imitation that must be mentioned. I mean the imitation of one kind of art in the materials of another. This has always been a bone of contention among artists. Ghiberti was greatly censured for treating his wonderful bronze gates at Florence more in accordance with the principles of painting than with those of sculpture; but this did not prevent Michael Angelo saying they were worthy to be the gates of paradise. Then, we sometimes see sculpture imitated in paint, and the result is only fit for the entrance to a circus or penny gaff. Some years ago the critics found that water-colour drawings began to look as rich as oil paintings, and cried out accordingly. The alteration of a word set everything right; the artists called their " drawings " " paintings." Simple are the ways of genius; the critics were content.

Some photographers have been accused of imitating sepia drawings. I don't think this has been intentional. The art is in a transitional state, and, if in the search for perfection, the results of one art have looked for a moment like those of another, it surely may be excused. When I get short of defensive argument, I like to think of a little incident of years ago. When specimens of

Adam Salomon's wonderful portraits were first brought to England, a dear friend of mine worshipped them, as indeed, did all of us. Not the mildest word of adverse criticism was allowed. You had to look and wonder. One day I ventured to humbly suggest of one of them that, perhaps, a straight line from corner to corner, cutting the space into two equal triangular halves, was not quite the best composition the subject allowed. I was answered sharply, " Perhaps he was working in that direction." Therefore it must be plain that the critic must know what the artist meant before he ventures to comment upon what he has done.

CHAPTER III.

THE STUDY OF NATURE.

𝖂HEN old Caleb Plummer, the toy maker in " The Cricket on the Hearth," got an order for barking dogs, and asked permission to pinch Boxer's tail, that he might " come as near nature as possible for sixpence," he displayed the true spirit of the real artist who insists on a near acquaintance with the subject he has to represent. Doubtless he afterwards suffused his work with the true spirit of art, but he was right to begin by making a close study of nature. It was this ardent naturalistic artist, it will be remembered, who was so anxious to improve Noah's Ark, but found it could not be done at a remunerative price.

I sometimes wonder, when I am out in the field with photographers, whether they get as much enjoyment out of their pursuit as it ought to afford. Photography, when it is not exclusively confined to science or trade, should be a combination of many studies, the greatest of which should be that of a group of which visible nature is composed, because it is in nature we find our subjects; and the least that of the simple means by which photographs are produced. There is no comparison between the knowledge required to select or arrange a suitable subject to make a fine picture and the mere mechanical reproduction of it in the camera. A little thought will easily make this clear. Of the many thousands of technically perfect negatives taken in the year, how many are fit for exhibition? I am afraid it would be an exaggeration to say one per

cent., the cause being that the operators have mistaken the best method of studying their vocation, and made chemistry, which is the preparing of materials, instead of photography, which is the applying of them to their proper use, the be-all and end-all of their existence.

There should be no question that, other things being equal, he who studies nature most will make the best pictures ; the man who knows most sees most, and enjoys most ; the artist should learn to see nature with the eye of an eagle, that he may represent it with the poet's vision, and I think it is also true that a knowledge of nature will make up in a great measure, for deficiencies in other directions. Yet this is sometimes denied. Every other kind of artist but the photographer knows that there is little fear of his coming too near to nature ; the photographer has to fear his work becoming too easily a thoughtless mirror. I have mentioned this subject in the last chapter, and need not say more here, but it may be worth while to say a few words on the value of a study of nature apart from his art, to the artist.

All artists agree that the only source and inspiration of art is nature, and that the closer we get to her, so that we do not neglect the art we employ in representing her, the better. It must follow then that the more an artist knows of nature the better, even if that knowledge does not bear immediately on the work on hand. Now what do we find of this general knowledge of nature among some artists? Let us contrast the pre-Raphaelite of a former generation with the impressionist of the present. It has been my good forture to know many of the former and some of the latter, and I have spent much time in the country with some of them. The broad result of my observation is

that the old school delight in a minute study, and understanding of nature, while the new school purposely avoid and half-shut their eyes to all except one phase of it.

The first shall be an old friend who, before he recently died, became one of the most popular painters in the land. To spend a spring or summer's day with him in the country was a liberal education. To him all knowledge of rural nature seemed instinctive, and it bubbled from him as from a spring; not as a lesson but as a delight. There was not a wild flower he did not know; a bird note he did not recognise. His discourses on bird and beast and fish, not as a scientific vivisector but as a lover, were interesting. He knew their times and seasons and where to find them; what they feed upon, which one is harmful, and which beneficial to the farmer and game preserver. In some country places, where he was always a welcome guest, old traditions survived as to the injurious habits of certain birds and "vermin," but they gave way to his entreaties, and the owl and kestrel are no longer nailed as felons to the keeper's kennel. The wiser knowledge he has spread has saved many an innocent bird from destruction, and Mr. Velveteens now takes as much pride in showing rare creatures on the wing, as he formerly did in crucifying their grisly corpses on his wall. It was a pleasure to sit by the rippling stream with our friend and talk of fish and fishing, and angling entomology; the strange transformation in the insect life on which trout and grayling feed. Moths and butterflies were intimate friends of his, and he was as learned in knowledge of folk-lore and weather-lore as any one to be found in all the country side. And while we talked he sketched. Here is an example of his work, showing the wonderful skill and loving care with

which he studied for study's sake. The sketch given on this page is one only of many hundreds, and of course very much reduced.

The other painter I have in my mind's eye is a vast contrast to my student friend. He seems to be afraid of nature. " I don't know a buttercup from a butterfly," he said to me contemptously one evening as we walked through the fields. " May I long be kept from any such useless knowledge, such petty details would interfere

with my impressions, and I take the poetic twilight view of nature, there is nothing else worth painting." It would not be fair to say that all of each kind are alike, it would be even untrue, but the two I have described are certainly typical of the two schools.

It must be admitted that an intimate knowledge of nature may not be so generally useful to a photographer as to a painter. Ignorance may allow a painter to make a great many mistakes, of which the nature of his art absolutely prevents a photographer from being guilty. It is true here that " Art may err, but nature cannot

miss." A painter may paint blooming hawthorn in a picture representing "May Day," which would be untrue, as the blossoming "May" does not appear until long after the first of the merry month, or even old May-day, and nature would rebuke the photographer who looked for the blossom so early. Or he may be guilty of the oversight of Fred. Walker, who in his most pathetic picture, now in the National Gallery, "The Harbour of Refuge," painted the daisies wide awake and open in the twilight, when nature closes them up and sends them to sleep long before sunset. These would be, perhaps, trivial mistakes, but I have seen paintings containing the flowers of all seasons mixed together, and as Shakespeare says :—

"At Christmas we no more desire a rose,
Than wish a snow in May's new fangled shows;
But like of each thing that in season grows."

I am afraid this can be taken only in a poetical sense now. A rose at Christmas seems a flower in season in our time. By an odd coincidence I am writing in Christmas week, and on my table is a glass containing three lovely Maréchal Neil roses which perfume the room. And this suggests a question. Are these roses works of art? Nature may have had some little to do with their birth, but she never produced such results as these unaided. She could not produce a rose of any kind at present, for there is a foot of snow on the ground besides other impediments. They are the final, wonderful result of a greenhouse, a gardener, and not to put too fine a point upon it, some chemicals. Which is the artist, the gardener or the greenhouse, the photographer or the camera? Why, the man who uses the tools and materials, of course.

A closer study of nature may teach the photographer many things useful in his art, such as how to use a suitable sky to his landscape—a simple matter that always

seems to be going wrong ; and it must infallibly lead him
to other subjects than the usual castles, abbeys, and
churches.

Of the studies most useful to the artist those of
botany and natural history come first. Some acquain-
tance with the birds and beasts and flowers adds delight
to a country walk. To know the names of the wild
flowers ; the season to expect those which are strangers
during part of the year ; to mark the coming of the
migrants ; to note the arrival of the cuckoo and the
nightingale ; to mark how true to time nature always
is. These are the simple pleasures that artists should
love. One of the most artistic studies is that of meteor-
ology, particularly if folk-lore is joined to weather-lore.
Meteorology in landscape may be called the master of
effects ; it calls our attention to the sky, a part of nature
that familiarity has almost deprived of beauty. We see
so much of this wonderful everyday show that it has to
become very extraordinary in shape or colour or we do
not think it worthy of our attention.

Finally, a better acquaintance with nature would
help those critics, if they cared to be helped, who now
glimpse only at nature and evolve truth from preconceived
ideas, or from their inner consciousness, to creep a little
nearer to facts. They would learn that nature had not
one mood or expression only, but that she assumes so
many forms and moods that a long life would scarce
suffice to read her correctly ; that she is full of apparent
inconsistencies and perplexing paradoxes that mock the
wisdom of the wisest.

CHAPTER IV.

THE USE OF NATURE.

IN the last chapter the study of nature has been recommended as the essential foundation of art. In art the composition that is not properly balanced is bad, and if this book is to have any excuse for laying claim to art quality, we must introduce a little balance here. The fault of most books on art is that the authors make the serious error of mistaking nature for art, and glorifying her accordingly. Nature is not art at all, except in Sir Thomas Brown's sense that " Nature is the art of God."

Let us consider Nature in relation to our art. Nature is raw material which in our alchymical cameras we convert, when successful, into pictures. The camera, or the use of it, should be the predominant partner.

Nature bears the same relation generally to other means of art as to photography, but photography, although one of the most exact means of representation, is also, and partly because of it, one of the most limited means of interpreting Nature. Photography is constricted by compulsory truth. This truth is often used as an excuse for misinterpreting Nature.

Fact is always solid and self-satisfied; truth is often satisfied, and at her best when merely suggestive. Truth is often more beautiful when merely hinted than when proclaimed from the housetops. Truth is never beautiful when blatant. Fact is often intolerable.

The photographer must accept all the help that Nature will give, but he must not set her up as a fetish.

" Let Nature be your teacher,"

is a pretty enough sentiment, and not altogether bad if taken in a wider sense than its author meant. If understood to mean " let Nature teach you what to avoid as well as what to select," the teaching would be admirable. But Nature knows nothing of art. Wordsworth himself, when he confined himself to pure poetry in " Intimations of Immortality," was a greater artist than when he descended to Naturalism in " Peter Bell " and other verses, which are all nature and no poetry. What we want is a work of art, not an imitation of Nature. An exact representation of Nature, if we could get it, would be a great curiosity, but not a picture. Fortunately, as a matter of fact, a close imitation of Nature is an impossibility. Nature resents the flattery and makes it ugly. The student who hopes to compress some miles of chromatic nature into a few inches of monochrome photograph is of a sanguine disposition. The true artist feels about the matter as Shakespeare did about his representation of Henry the Fifth's army.

> " And so our scene must to the battle fly,
> Where, (O, for pity), we shall much disgrace—
> With four or five most vile and ragged foils,
> Right ill disposed, in brawl ridiculous,—
> The name of Agincourt."

Yet " by his most potent art " the great poet gave a wonderful *impression* of the famous battle.

I recollect, many years ago, reading a line by a writer who was in advance of his time. It ran something like this : " Before you think of art in connection with photography, pray get rid of the notion that you can give an imitation of magnificent Nature by covering a small piece of pink albumenised paper with a platitude of sharp detail."

On the other hand you must not defy Nature. Study her for all she is worth. Get all you can out of

her. Learn at least some of the visible secrets of the earth you photograph. I have even found geology and astronomy great aids to pictorial effect. Some knowledge of the latter once saved me from representing a three-quarter moon upside down. You cannot know too much about the sky. Excuse me for suggesting that in your present state of knowledge or ignorance you do not know the difference between a sunrise and a sunset. Read awe-inspiring books that are sentimental but teach not ; go into ecstasies ; worship open-mouthed if you feel it does you good ; but in attempting to produce artistic effect let *Art* be your teacher rather than Nature. There could not be a more devoted naturalist and Nature lover than myself ; but in picture-making I cannot help looking upon her as the sitter who must not dictate, rather than as the artist or teacher. She knows nothing of composition, or light and shade, yet we are always finding beautiful, wonderful and grand scenes. These are not the result of intentional art on the part of Nature, but it should be the photographer's business to secure Nature's flukes, and convert them into his own deliberate results. Rob Nature always. She never minds, but keeps on smiling or frowning. She sometimes looks stupid when she is doing neither.

Nature never cares whether she has a sky or a fore-ground ; the photographer should take care that the bit of her he selects has both, and it is in these departments he has most control. An artist ought to be able to teach Nature a lot about the use of the sky in a picture. Photographers sometimes let her have her own way ; and she sometimes, it must be admitted, flukes a success, but it is not safe to rely upon her. Nature's idea of herself, when she borrows a camera and tries to reproduce her own image, is that she usually appears with a white paper sky. It is necessary for the pencil of

c

light to get into the hands of the artist if that white paper is to be artistically covered. She sometimes offers you a good foreground ; make the best of her good gifts and reject the bad ones, but don't take the good too much for granted. It may be " good enough," but good enough is only tolerable and not to be endured. The best possible should be the thing demanded.

CHAPTER V.

SOME POINTS OF A PICTURE.

IN laying down the law, or definitely stating what should be and what should not in matters of taste, a writer leaves himself open to the charge of putting on the fetters of law and rule and endeavouring to cramp genius. Anything so arbitrary is not intended in this little treatise. My object is to call attention to some of those qualities that may be reasonably looked for in a picture, and not to dogmatise, or attempt to interfere, in any way whatever, with the best quality in an artist, individuality.

It seems scarcely necessary to point out that there are pictures and pictures, but a palpable truism is often useful. There are also many means by which pictures are made, and the triumphs of one means of art are not always to be judged by the standard of another. A modern oil or water colour painting is not to be compared to Michael Angelo's "Last Judgment," or Raphael's "Transfiguration"; it can only be humbly claimed that they are all of the same family, and that whatever the means, the same general idea of production is common to all.

It is not a consideration of what we should look for in the highest art that would be useful here, and we need not enforce Ruskin's definition, true as it is, that "the greatest picture is that which conveys to the mind of the spectator the greatest number of the greatest ideas"—that would be expecting too much, and would be entirely opposed to the modern frivolous notion that pictures should present no ideas at all, except of the cleverness of the

painter in laying on the paint. Ruskin is now judged to
be old-fashioned in saying that " no weight, nor mass,
nor beauty of execution can outweigh one grain or frag-
ment of thought," and a picture with a thought in it is
now dismissed by the latest fashion in criticism as
"literature in the flat." A more recent writer than Mr.
Ruskin, however, agrees with him. Mr. Quilter says,
" The great artist is a man whose imagination is ex-
ceptionally aroused by this or that beauty of natural fact
or spiritual consciousness. He is not the man who sets
to work with the precision of a mathematical instrument
to work out a problem in colour and form." But this is
a changing world ; and although it is my opinion that
the principles of art are eternal, that kind of doctrine is
out of place in a state of life which is ruled by caprices
and fashions. What is right to-day was wrong yesterday,
and will be wrong to-morrow. Perhaps it is well that
in matters of taste a good deal of freedom may be allowed ;
my own poor taste prefers the pictures which give some
evidence that the artists have something to say as well
as do ; those in which the poet sings, in preference
to those solely painted to show the skill of the producer.

But whether a picture possess thought, or, by desire
of the artist, be utterly thoughtless, I cannot admit that
it has merit if it is not interesting. The first grand
principle then should be, *be interesting.*

It is often said that before a critic gives any opinion of
a work, he should first ascertain what the artist intended,
so that he may look upon it from the creator's point of
view. This may be desirable, but I do not think it of
great importance. The question is, What does the
artist tell us in his work, and how has he told it ? Was
it worth doing ? Is it interesting ?

Perfection is not necessary to secure interest. A
picture may be interesting for many reasons. On the

whole the most lasting interest will be found in a picture for its beauty, a quality that never fades; but we have seen of late years that a picture may attract a good deal of attention for what we, perhaps in our ignorance, call its faults. When the usual welcome guests are otherwise engaged, the maimed, the halt, and the blind are called in, and become, doubtless, interesting. We are in an inverted world, and amid many confusions.

The wild eccentricity and demonstrable faults of the new " Glasgow School," for instance, and the " New Art " (on which the painters must work with their tongues in their cheeks, and we cannot help joining in their smile at the credulous, wicked as it is), are extremely interesting ; they may even remain in the memory, if only in the guise of nightmare ; still they are interesting, and therefore attractive as a passing fashion.

The one intolerable defect in modern art is dulness. Now this is the prevailing feature of photography, and it has been unfortunate—let us hope an aberration of the past—that any attempt at originality in our art has been perhaps not a little snubbed by some of those who have acted as its foster-nurses, but were perhaps afraid of finding forward children " grow out of their knowledge." I say it, with many apologies for the discovery and much regret, that in a thousand photographs, nine hundred are all alike except in subject, and all are dull. There seldom seems to be any attempt to be really interesting or original ; if it is not a view of one place it is of another; there is no difference of treatment, no attempt to show that the photographer has any separate existence from the rest of his brethren. As Sydney Smith said of a volume of sermons, "Their characteristic is decent debility." I exempted one hundred from the dull thousand. It is perhaps, too generous a proportion ; anyway, it is' encouraging to find that the number of

those who take the art seriously is daily increasing, and that the " new movement " which is to regenerate the love of photography as an art is penetrating the mass of photographers.

The intention of most of the art of the present day should be to please. This definition need not exclude tragedy. Many pleasures are associated with painful feelings. Jessica was "never merry when she heard sweet music," and Mr. Ruskin maintains that there is no such thing as fine colour which is not sad. But to sink below tragedy becomes outrage, without any pleasing compensations. The art of the painter, the writer, the actor, the reciter, is sometimes full of horror and freezes the blood, chills the marrow, and produces other un-pleasant sensations. This is bad art. Yet some people are never happier than when they wallow in the terrific. It may gratify the vanity of the artist to make startling effects, but art should be produced for the delight of the beholder.

We will now run briefly through those other qualities which we may reasonably expect to be present in a good picture otherwise interesting.

In landscape we must have not merely the facts, but the grace and charm and expression. Truth is most talked about and least understood of any of the great qualities of art. There is a common delusion that facts are truths ; now, a fact is often only a small part of a truth, and " a half-truth is ever the worst of lies." In the early days we admired a photograph of a landscape, with a white-paper sky, as " so true " ; now we are beginning dimly to recognise that however near the truth the landscape might have been, from the fact of its having a lie, in the shape of a white sky attached to it, the whole was only a half-truth. Any attempt to represent nature perfectly must necessarily fail. Read the words of

G. F. Watts, R.A., whose art all creeds respect : " In our seeking after truth, and endeavour never to be unreal or affected, it must not be forgotten that this endeavour after truth is to be made with materials altogether unreal and different from the object to be imitated ; nothing in a picture is real. Though art must be founded on nature, art and nature are distinctly different things."

It is not the mere copying of nature that gives artistic delight, so much as the intellectual pleasure to be derived from getting the best effect out of any given materials, or adding a beauty to that which is already beautiful. In photography, fortunately, we are gradually emancipating ourselves from the trammels of rigid fact, and are rising into the finer regions of artistic truth. " Who can paint like nature ? " asks the poet fatuously. " Who wants to ? " replies the artist.

Imitative illusion is a trap for the vulgar. A scene may, and should, be represented truthfully, but some artists can see and represent more and greater truths than every passer-by will notice. Photographic means may be limited ; he may use a " machine," nevertheless the photographer, who sees most will represent more truths more truthfully than another.

In aiming at truth we must not forget the spirit. Exact copyists are never original ; but there is some excuse for the painter copyist, his imitation of detail may be at least clever. Now this can never be with the photographer as I shall have to repeat several times as I go along. There is no particular cleverness in getting a sharp impression of most intricate minutiæ, and the surprise and wonder of the " finish " of a photograph vanished many years ago, when an increasing knowledge of the art rubbed off the novelty. There must be some- thing more than detail to attract pleasurable attention now. Gerome, the great French painter, puts the

difference between exact copying or imitating and artistic truth into a few words : " Some know how to copy a thing, and will reproduce it exactly; others put it into poetry, charm, power, and make it a work of art. An abyss separates the mason from the architect." I have heard it argued that however artistic a photographer may be, his picture can have no art in it, because any inferior photographer that happened to be passing could take a shot at the subject he had arranged and get as good a picture. Even if this were true (and it is far from it), the taking advantage of other men's pictorial ideas is no more art than American piracy of books is authorship. A picture, especially a photographic one, begins at the word "go"; let us say from the time the maker sees the subject and determines what to do with it. This includes the intention, selection, and arrangement, as well as a good deal of legitimate treatment of the negative and in the printing. I have myself finished a photograph five or six years after it was begun. Much mischief is done by the common notion that a photograph is essentially completed in an instant. It is an accident that much of what gives a painter trouble is produced for the photographer by easy means. Every art has its difficulties and facilities, and drawing is not a stumbling block to the photographer—he has others.

It will, of course, be understood that if the picture is to be a work of art it must be a work of order. Harmony of lines and parts, breadth of effect, observation of values—in short, the grammar of art must be observed. I have written so much on composition elsewhere, that I need not go into details here about these aids to the pictorial. Just as a poem ill-spelt, or as a musical instrument out of tune, jars on the ear, so does an ill-composed design appear to the educated eye. Instead of my own words on this subject, a few by a writer

I have already quoted may be more convincing: "It may be doubted whether great landscape is possible without the elements of composition entering very largely into the scheme. Certainly no great landscape art in England has as yet existed which did not depend almost mainly upon this quality. And it would be interesting to show how large a share is played by this characteristic in the apparently simple works of David Cox and De Wint."

Mannerism, if not offensively apparent, is to be welcomed. It is a stamp of individuality, the hallmark of the master, but it must not be the chief object in the piece. All great artists have their mannerisms; it is the mediocre, or inexperienced artist who has none. We don't want a catalogue to recognise the works of a Leighton, a Millais, a Moore, or a Tadema. A poet is known of his numbers. It is a poor ear that cannot differentiate the song of a Shakespeare, a Milton, a Pope, a Browning, or a Tennyson. Moreover, the picture or song of a great artist is not imitable; it is otherwise with the pretentious, the empiric, or the mountebank. The contortions of the sibyl are easily reproduced. In the present state of photographic art eccentricity may be safely encouraged.

Notwithstanding that mannerism and eccentricity are welcomed, they must not be admitted at the expense of sincerity. No art comes to any good that is done "from the teeth outwards." There must be a feeling that the photographer did his work with sincerity and conviction, and not for the fun of the thing. Let a man have implicit confidence in his work while he is about it, it will be all the better for his belief in it; when it is finished let him doubt for ever after and try to do better. An artist cannot take too great pains over his work, but in the final result the evidence of impulse should pre-

ponderate over that of preparation. There should be no smell of midnight paraffin.

In portraiture we have a right to expect much more than has yet been done by photographic means. Occasionally we meet with a portrait of which those who know the subject may say, " That is the man," not only the outward and visible man, but a strong suggestion of the inward and spiritual grace; not only the form of the features, but a potent hint of the character. It is not necessary to idealise the man into something more than reality by aid of retouching, but the clever artist ought by successful treatment to bring out the best points of his sitter before he presses the button. Let it, therefore, be a point in a portrait that, in addition to pictorial effect and good technique, it shall have character. In many portraits, and some of them the most pretentious, the photographer seems to have been afraid the head would attract attention, and calls off the too inquisitive eye by aid of accessories. This is the very false gallop of art.

Surprise is one of the elements of successful art, and there must be contrived some mystery to delight or exasperate the average connoisseur. The originality of unexpectedness may be shown in several ways ; in the novelty of the subject and treatment, and in the means by which a picture is produced. Yet original successes have their comic drawbacks. When some who practise the art see a successful rendering of a new effect, or an effort at originality, they prefer to regard it as an experiment—chemical by preference, but optical will do. That lovely and most natural smile in a portrait, or the passing gleam in a landscape, is not admitted as contributing to the success. The catalogue is immediately consulted for particulars as to what process, exposure, development, etc., could have produced such a result ; if

the photographer is at hand he is asked for details. This puts him on the horns of a dilemma. If he explains he probably gives himself entirely away. It may even be impossible to explain ; beautiful things are often too simple for description ; the lovely iridescence of the bubble is lost if you are rude with it. If he refuses to give information he is, perhaps, considered selfish. Now, what ought to be done in such a case ? The first duty of the artist should be to his picture, and to the question, How is it done ? may, perhaps, think it too bumptious to say with the Assyrian, " By the strength of my hand I have done it, and by my wisdom;" but he may be allowed to reply simply, with Prospero, " By my so potent art," and that should suffice. His questioner may be also reminded that there was more knowledge of the kind *he* was looking for to be found in a shilling manual than all the pictorial photographers could give him. A photographer who consents to describe every detail of process and the little arts he uses, is like the poet who insists on prefacing his poems with a treatise on versification and the use of the rhyming dictionary. It is not to be wondered at if the poetry evaporates in both cases—merciless vivisection destroys the delicate bloom of mystery which always adds a subtle charm.

CHAPTER VI.

SELECTION AND SUPPRESSION.

IT has become a favorite saying that art is selection, to which should be added suppression. Yet this is only partly true. Selection has much to do with art; very much with the art of the photographer, but there are many other things to consider before the work of art is complete.

For a pictorial photographer to try subjects which by no possibility would make pictures, or upon those that are only very nearly good enough, or contain ugly features which are not removable, or to be hidden, is a sad waste of time and trouble; to secure a subject that might have been improved by some addition, suppression, or by waiting, should be a cause of life-long regret for a lost opportunity, or to wish for a bad memory, for there is nothing so depressing as the recollection of "might have beens."

Painters say in considering a subject, "Will it paint?" A photographer should ask himself "Will it with my materials make a pictorial composition, is it suitable to my art?" He should consider whether he could remove blemishes, or add to its pictorial capabilities; he should ask himself if he has got the best aspect of his subject; the best time of day; if the scene would be improved by figures, and, a question often forgotten, if he really wants a photograph of that particular subject. But on considering I withdraw this last observation. If photographers took to asking themselves questions of this sort it would be bad for the plate makers.

Here I will venture on a digression. It is the fashion of those who confound nature with art, and take only a superficial view of either to say that everything in a picture should look "natural." This is right to a great extent, but not always all the way; it depends upon what is taken to be natural, and above all, as the object is a picture, whether the "natural" be pictorial. To "look natural" is commendable, but it is not the end and aim of art. Photography itself ought not to be blamed for sins committed in its name. It is the result of want of thought, bad taste, stupidity or ignorance, that in nine cases out of ten, or more, when figures are designedly introduced into a photograph, they appear stiff, stark, and utterly unnatural and out of place. Now according to the usual perversion of things all the blame is put upon the method; it is photography and not the photographer that is found at fault. Figures are condemned because the placer of them is sometimes condemnable. That it is not the fault of the art, but of the—operator (I won't call him artist in this connection), has I think been sufficiently shown, and I go so far as to say that more natural action, more effect of spontaneity in figures can be got, in capable hands, by posing, than is ever obtained by instantaneous exposures, made without the knowledge of the victim. Who ever saw the petrified figures of men standing on one leg in the street before the "so natural" snapshottist took them unawares? Who has not wished in looking at a chance shot that this figure was more to the right or left, and that figure more in the picture, or away altogether? Nevertheless the hand-camera is a splendid tool when used seriously.

Many of the most beautiful scenes in nature are quite outside the range of photography or, indeed, any kind of art.

I don't know if photographers have noticed it, but it oftener than otherwise happens that the subjects select *them* rather than the other way. Now the best pictures are produced when the capable artist is the master, and takes the lead in the partnership. And it depends in a very great measure on the strength of his lead whether the result is good or bad, or only of that neutral quality called mediocre.

Although schools of art vary in their methods they all agree that the source of all art is nature. Some think the most beautiful nature makes the best art; others prefer the ugly, as more suggestive and pictur-esque. It is possible that all are right in their degree; much depends upon the quality of the artist. If some of our modern painters have not succeeded in convincing us that high art is to be extracted from low music-halls or squalid vulgarity, it is certain that some of the Dutch artists succeeded greatly with some even more disgusting subjects. The difference in procedure between the two schools is that the music-hallers employ a convention which they persuade themselves is close to the nature *they see*, that is, that they constrain themselves to see, while the Dutch masters used a convention by which the skilful art was hidden from all but experts, and experts obtain much of their pleasure from these productions by discoursing on the extreme skill with which the convention is used to give the best repre-sentation of nature, and to hide itself. This subject, however, is considered in another chapter.

Beautiful subjects may be obtained from very simple bits of nature without any aid from figures or other arrangements. A broken bit of a river bank and its almost always picturesque surroundings; twilight subjects which seldom require outside help; seas and skies, or very extensive views, but I prefer to see some

cause, beyond a mere study of tones or masses to
account for the picture being painted. I certainly do
not wish to appear to belong to those who parade their
indifference to the quality of the thing said, and think
only of *how* it is said. Let us have the best workman-
ship, certainly, but let us bestow our workmanship on
worthy objects. Let us put our poem into the very
best grammar, but let us also take care that it *is* a poem,
not merely grammar. If anything must give way I
really think I could spare the grammar rather than the
poetry, or at least a little bit of it. Harmony, tone and
texture, admirable as these qualities are, are not incom-
patible with the employment of subject. The modern
objection to incident is too often the result of want of
thought, or lack of imagination.

But if figures are introduced into our pictures they
must be done with confidence and knowledge.

It must be admitted that a picture which tells you
something worth the telling, has more interest than one
that has nothing to say except the professional fact that
the artist can paint or photograph with skill, and it
follows that a landscape with a figure or figures, where
figures are appropriate, is better than one without such
embellishment ; and if those figures are "doing some-
thing," or embody some incident, they are still more
interesting. In a number of the *Universal Review* a
writer in incidentally alluding to one of the idyllic
painters, says :—"His landscapes were in some sense
short stories. An intention ran through the work : a
hint of meaning as well as of beauty. A bit of nature ?
—yes ; but a bit of man too—that was the subject
matter of his pictures as it has been the subject-matter
of all really great landscape art."

It is in the use of figures that so many exhibitors have
failed. The ambition has been often worthy, the ideas

in many cases very happy, but the carrying out has not done justice to the thought. The intention has been better than the execution. This is not unhealthy, because it is easier to better the execution by study and practice than to invent, although invention also is amenable to cultivation. We meet with attempts at all sorts of incidents, chiefly of the rustic or picturesque order—the kinds perhaps most within the reach of photography— but few of them are presented with the spontaneousness and "go" that is a characteristic of good art. When the first suggestion a figure makes to you is that it stood for the photographer, you may be sure there is something wrong about it. We know and admit that in nearly all cases, especially in the best art, when nothing is left to blind chance, the figures are carefully placed and studied, but if they look like it there is something wrong, but it is certain that the artist and not the art is in fault. I might be told that this is not true of instantaneous effects, but I am writing now of those pictures in the execution of which nothing is left to accident, not of those of which we may say with Barry, that " divested of design art becomes a mere toy, a mechanical bauble, unconnected either with the head or the heart."

This spontaneous naturalness in their figures seems to be one of the greatest difficulties to photographers, old as well as young, and should be recognised as one of the worlds yet left to conquer. It is not easy to advise how to attain this supreme quality. A great deal must be left to the power of will of the operator, and his skill in influencing his figures, something to his perfect knowledge of what he wants to produce, and something to his nerve in seizing the right moment. I also think it is possible to kill with too much care, and that much may be lost by hesitation or further consideration, for waiting models become stiff and fleeting effects quickly pass.

D

The illustration below is an example of how a good subject, but with some awkward lines in the foreground, which make it unfit in itself, has been made into a picture by the introduction of figures. Try to imagine the scene without the figures—the boat may be left. However interesting the screen of trees there would be no picture. In this case something has been added to the atmospheric effect by allowing the mid-distance to be a little out of focus. The use of small touches of

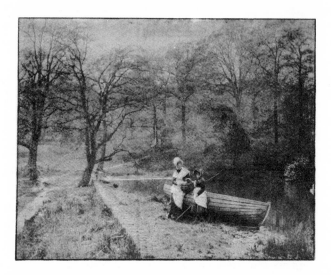

black and white is also shown. This picture is interesting to me as being the first landscape I ever exposed on a gelatine plate (15 × 12). This was in May, 1880. I took four plates only to Wales, experimentally, and on developing at home was astonished at the result, and at how easy picture making away from home had become.

The illustration on next page shows how large figures may be used.

It is a curious thing about the art of photography that the more skill and art you display the more you are congratulated on your *luck*. The less you rely on chance the

more you are thought to depend upon it, and you are paid awkward compliments for which you do *not* feel grateful.

One of the favourite objections of the modern critic is that some painters sacrifice much to produce the effect they try for and achieve. To my mind the courage to sacrifice, if indeed it may be called courage to sacrifice what we do not want, is a great merit. It is the dis-inclination to sacrifice parts that are perhaps beautiful

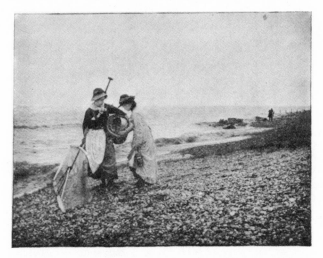

in themselves, but out of harmony with the whole, that renders so many photographs inartistic and worthless. It is worth while then to consider if part is not more valuable than the whole, which in art it almost always is, and if it is possible to get rid of what you do not want ; whether you can get rid of it altogether or hide it. Different subjects require different devices, but there is great virtue in shadow, and shadows change all through the day.

CHAPTER VII.

COMPOSITION.

A KNOWLEDGE of composition, as studied, used, and hidden—for to hide the means, or not leave them obtrusive, is part of the art—by painters (and indeed all kinds of artists, even down to the black and white copyist of photographs for the manufacture of original illustrations) is of the greatest service to the photographer in the selection and treatment of a subject.

The effects of a knowledge of composition should be felt as much in a simple portrait as in the most elaborate subject. The function of composition is often greatly misunderstood. It is said to be a pedantic and conventional method of arranging the separate forms and masses of a picture so as to make them agree with certain preconceived ideas; a sort of Procrustian bed which all subjects must be made to fit. Nothing could be further from the truth. On the contrary, the study of composition teaches how to get the greatest amount of variety, but also how to keep that variety together without straggling; variety in unity, or, to use the motto of a famous artistic photographic club, it teaches " Liberty and Loyalty."

Composition was evolved throughout the ages as a help towards obtaining the most pictorial effect that a subject would admit of, the picture may be visibly very little indebted to its use, but it could not fail to give the artist confidence as he produced his subject. There are some unfortunately who will persistently look upon any arrangement of lines as an exercise in geometry, and when they find such aid does not help them to pro-

duce pictures condemn it, as those condemn figures in landscape who cannot pose a figure, or have no power of pictorial control of a group.

I have gone so much into technical detail in another book* that I will not trouble the reader with the same matter here, but will treat the subject more generally. While apologising for referring to myself, I will take the opportunity of saying that I attribute any facility and success I may have had as a picture maker to a very thorough study when I was young of composition, and all that goes to the construction or putting together of a picture. It is true that very much has been written on the subject that could be of no use whatever, except, perhaps, as a training for the mind in the sense of pure mathematics, but without some acquaintance with the broad principles a photographer can but grope in the dark after his effects. He can only wonder, indecisively, " whether that would make a picture." I cannot do better in advocating a return to a study of composition than claim the support of Mr. G. A. Story, A.R.A., who recently read an admirable paper on " Photography from an artist's point of view." He remarks, " Now I hope you will excuse me for saying that if photographers copied fine pictures by the great masters, it might be of use to them from an artistic point of view, and enable them to improve their compositions and effects. The same laws which apply to art apply to photographic pictures, and the more the photographer studies those laws the better will be his pictures. He has none of the difficulties of execution to think of, none of the difficulties of that craft which it takes years to learn, therefore he can devote some portion of his time to studying light and shade and composition, or the art of making each part of his picture help the other parts. One of the great

* Pictorial Effect in Photography. Sampson Low, Marston & Co.

drawbacks to photography, at all events in the majority
of cases, is that this art is either not considered or not
known, and nature is too frequently taken just as you
find her (I know there are many exceptions), but the
consequence is that each part, instead of aiding the unity
and assisting the harmony of the general effect, is too
often fighting with it and destroying it, and that perhaps
is one reason why we soon get tired of those views that
are taken haphazard by people without taste." This
admirable writer and artist says further : " This art of
composition is often condemned by young painters
because they are apt to confound it with certain tricks
of art that were too much insisted upon at one time, but
composition is much more subtle as well as reasonable
than they suppose, and they find themselves un-
consciously struggling after the very thing they affect to
despise. I mention this because it is the fashion to talk
about picture making as a thing to be treated with
contempt, but it is only those pictures that are properly
made and beautifully composed, concealing at the same
time the art by which they are done, that live, and that
we can live with, and never get tired of, because all
within them is at peace and in tune, like a happy friend-
ship. But as for the other sort, all is at sixes and sevens
—anyhow, every bit is wrangling with the other bits, it
is a quarrelsome thing, and one that we do not care to
have anything to do with—such works as the latter are
the result of making it easy and of ignoring the first
principles of art."

This is admirably and truly said, although the writer
is not quite correct in saying that the picture making
photographer " has none of the difficulties of execution
to think of," and that, as he says in another part of his
paper, " it all comes out of the little box." But he
is of course thinking as he says this, of the ordinary and

everyday practice of the process. It would be as easy
to say of a painting that it all came off the end of the
little brush.

Certain points of composition are essential as
elements of a picture. No picture can give complete
satisfaction to the eye that has not harmony of effect.
This harmony can only he brought about by the union
of various qualities, of which *breadth* is among the most
important. Let us attempt an illustration in words of
this one point.

Take any moderately suitable subject. Let us
suppose a screen of trees with a varied outline, a little
water, and a bold heap of rock, with plants as a fore-
ground. Look at this subject at various times of day.
In the morning the sun shines flat on the scene. We
know that the sun shines; the heat and glare and colour
tell us that, but pictorially the excess of sunshine defeats
itself. No amount of perfect technical photography
would make that scene look sunny under that aspect,
or in any way interesting, because there is so much to
equally distract the eye. There is no effect of space ;
the foreground rocks sink into the middle plane ; the
bits of distance are lost. A few hours later the effect is
improved, but still the patches of light are distracting.
Try again after another two or three hours' interval and
this is what you will find. The sun has gone further
on his daily journey, though it is still early afternoon,
but he now leaves the screen of trees in broad shadow
as well as the water, which before had sparkled. The
broken meadow space and the foreground are in sunlight,
the rocks chiefly in strong shadow, with bits of sparkling
light and we have pictorial effect, very satisfying to the
eye, produced by breadth of light and shade. The
space is divided into broad masses ; the rocks
stand out boldly in the foreground, and are the

only very light and very dark parts of the picture, throwing by contrast the otherwise dark screen of trees into a breadth of middle tone, with faint marking out of secondary masses, while the great mass of foreground is in broad sunshine and the sunshine is emphasised by the small portions of extreme dark in the rock shadows. The sky, what little there is of it, has a few horizontal clouds, just breaking the monotony. This effect would be pleasing to the artistic eye without any reference to subject or detail.

Now it may be easily said that what is called "good taste," which after all is an educated instinct, would assist the student to select the best of these varying aspects of the same scene. True enough. Good taste would probably select the best, that is, the one distinguished for breadth. But it would surely be helpful to know why it was best, and by knowing what would probably be best, and why, to determine what to take and at what time of day.

As I have said, I do not intend to go into the details of composition in this book, I only want to arouse the reader's interest in the more advanced photographic art here. But I may go a little further.

No picture could be quite complete without mystery. This quality has never been so much appreciated in photography as it deserved. The object seems to have been always to tell all you know. This is a great mistake. Tell everything to your lawyer, your doctor and your photographer (especially your defects when you have your portrait taken, that the sympathetic photographer may have a chance of dealing with them), but never to your critic. He much prefers to judge for himself whether that is a boathouse in the shadow of the trees, or only a shepherd's hut. We all like to have a bit left for our imagination to play with. Photography

would have been a settled fine art long ago if we had
not, in more ways than one, gone so much into detail.
We have always been too proud of the detail of our
work, and the ordinary details of our processes.
Instead, however, of going into mystery wholesale, as
in a very much out of focus picture, we should dis-
criminate in our mystery. Show up what is worth
seeing, hide what is ugly, and play at hide and seek
with the rest. That is composition. A portrait with a
light background, separating itself sharply from a black
dress, shows the form absolutely and equally defined.
We call this effect "hard." It is a defect which a little
mystery would cure. Nobody but a scientist wants to
be told everything. To look at a perfectly defined
photograph is like reading a novel of which you know
the plot, nay, it is even less interesting, for you have the
satisfaction when you know the plot of a story of
judging how the author has written his book ; while it
does not give you a moment's pleasure to judge how the
photographer has done his work.

A picture should "draw you on" to admire it, not
show you everything at a glance. After a first satis-
factory general effect, beauty after beauty should unfold
itself, and they should not all shout at once. Let the
principal feature, as the head in a portrait, claim first
attention, and the rest follow. There is a great deal to
be done, even in our art, by the use of *emphasis*. This
is attained by concentrating the attention on one part of
the picture by so arranging that that part shall be
darker or lighter than the rest of the space, so that it
shall be more conspicuous. This can often be done
without violation of the truth of nature. And in art—
but it is difficult to get artists to confess it—truth to
nature has constantly to be sacrificed for the sake of
effect. The greatest artists have continually and

deliberately sacrificed truth to effect, and they would not have been the great masters we all acknowledge them to have been, if they had not done so. The art problem, in fact, is always not to show all the truth; what to sacrifice is of the last importance.

CHAPTER VIII.

EXPRESSION IN LANDSCAPE.

PHOTOGRAPHY has been struggling for fifty years to faithfully represent the stocks and stones of this world, and has succeeded to perfection, but glimpses of the spirit of nature have been all too rare. Our art has demonstrated the fallacy of the old notion that close imitation of nature without other qualities was art, for (as I have frequently pointed out) no means of imitation has ever followed nature so closely—so abjectly—and, perhaps, no representation of nature is further from art than the ordinary photograph as usually manufactured. Maps, plans, and diagrams of nature, have been and are plentiful, but anything beyond has been as scarce as photographs were originally curious, and when they ceased to interest as curiosities, photographs had very little left in them to satisfy the hunger of those who look for more in an artistic meal than dry bones.

A few of our craft have always struggled to forward the cause of photography as an art, but their individual enthusiasm had not met with any general response until a few years ago, when a small band of zealous photographers, tired of the apathy and almost contempt in which photography as a means of pictorial expression was held, formed an institution solely for the promotion of photography as an art, and their institution and its success have been imitated and followed—it would not be too much to say over the whole civilized world. The *Salon* has set up mental over mechanical photography, and the organisers are succeeding in their endeavour to encourage that class of work in which there is evide

of personal artistic feeling. In future the mere bare facts
of a scene will not be sufficient—there must be *expression*,
for even the most ordinary scene has its own character.

Landscape expression varies in form and intensity
with the hours. The freshness of spring, the heat of
summer, the gold of autumn, and the cold of winter are
phases of nature which we should not only be able to see
and feel in ourselves, but also to represent in our pictures.
There are other and perhaps more subtle aspects of
nature which are always before us ; the coolness and
freshness of morning, the heat and greyness of noon, and
the mists and glow of evening, are well within the powers
of representation of the photographer who can feel the
beauty of the effect, and knows how to take advantage
of all the resources of his art. The evanescent beauty
of sea and sky, sunshine, fog, storm, calm, are all
possible, given the mental quality in the photographer to
know beauty when he sees it, and what will make a picture.

In photography, as a rule, the hand has been
educated at the expense of the head ; the knowledge of
how to make the materials has become stupendous and
vast, and then it all stops—a mechanical art. The
student who wants to go beyond mechanism must
cultivate the emotions ; must get into closer touch with
nature ; must be able to grasp the scene in his mind and
feel its beauty, as well as capture it in his camera.

I will endeavour to illustrate what I mean by ex-
pression in landscape. To do this I must use one of my
own pictures.

It represents what appears to be an evanescent
phase of nature, one of those " lucky chances " on which
the successful photographer is always congratulated
however surely he may meet with them.

This picture—" Storm Clearing Off " (see frontis-
piece)—was not a snap-shot, but was produced by

deliberate intention ; I regret that it loses much effect by being reduced in size. The size of the original is 20 × 16.* The initial idea was the contrast between sunshine and storm, and the effect of rain. Neither the painter nor the photographer can hope to find the effect he wants without trouble, and I had to wait and watch, but the effect came in time and I secured it.

I am not going to destroy what little poetry there may be in the picture by explaining the details of pro-duction, or by leading off the student's mind into the laboratory; the illustration will answer my purpose if it shows what can be done, but I don't mind saying that happy chance had very little to do with it ; but it was certainly lucky that I had made an appointment with the sheep the previous day, I wish I could claim that the storm came by appointment also, or, indeed, came at all. But these be mysteries! The picture was done on a common, near Tunbridge Wells, yet I doubt if anybody could identify the scene with certainty. The effect, *although strictly from nature and true,* has so idealised the subject as to make it unrecognisable. I have taken only as much "fact" as I wanted.

During a heavy storm sheep pack together for mutual protection, and when the storm is over they gradually disperse to feed ; whether they did this on their own motion on this occasion, or by the help of clever dogs, is of no consequence, so that the effect is obtained and is true to nature, and if the natural appearance of the rain on the teeming earth has been *helped* by purely photographic means, what is that to anybody so that the result is due to close and constant observation of nature. Photography has been authoritatively defined as " painting by light," and what the spectator has to consider is, first, the pictorial

* See Frontispiece.

effect of the picture, and, in the next place, the truth of the effect. If he does not like it he has a right to object and pass on ; but to object rightly, and publish his opinion, he should consider first whether he is properly qualified to give an opinion.

CHAPTER IX.

IDEALISM, REALISM, AND IMPRESSIONISM.

CLOSELY allied with expression is the question of Idealism and Realism. Those who have only a superficial knowledge of the possibilities of our art contend that the photographer is a mere mechanical realist without power to add anything of himself to his production. Yet some of our critics inconsistently commit themselves to the statement that some of our pictures are nothing like nature. This is giving themselves away, for if we can add untruth we can idealise. But we go further and contend that we can add truth to bare facts.

A passion for realism is the affectation of the hour in art and literature, and is making some of our novels so dirty—in the name of art—that one scarcely likes to mention even the titles of them. It is the fashion to yearn for Nature, and to select her as bare, bald, and ugly as she is made, the particular kind being that which is the outcome not of nature, but of the errors of civilisation. But when we examine the matter closely, we find that no art to be successful, however it may try, can entirely dispense with idealism. The stage heroine studies her part in the hospitals and dies before the audience without omitting a cough, a gasp, or a groan, but she cannot do without the idealism imparted by slow music and the limelight ; the realistic novelist catalogues exactly the ugly, the sordid, and even the bestial, but he is careful of his "style" ; the painter ostentatiously seeks ill-favoured models, uninteresting subjects, anything will do so that it is " not literary," or amusing, or

E

instructive or interesting, but he is careful about his drawing and colour. The realism of the moment appears to select ugliness by preference, probably because it can be made more striking and sensational. There is still the possibility of realistic beauty, and this photography sometimes attains ; but a photograph is too often neither more nor less than uninteresting, colourless fact, without the negative merits of ugliness or the charm of beauty.

As I write I meet with the following which shows how exceedingly " mixed " some writers and artists are getting over some of the modern terms.

The author of a book on Velasquez calls that great artist a realist, on which his reviewer says : " It is difficult indeed to understand how the term could ever be applied to the supreme master of suppression and selection. There are some words which have lost all significance from the hard work put upon them. And realist is of the number. It has been asked to mean so much that it has ceased to mean anything at all. In fiction, realism is the glorification of the *Un*essential : it is that sacrifice of proportion which would exaggerate into a tragedy the drawing-on of a pair of boots; in painting it is the patient amassing of conflicting details, which exist, maybe, in nature, but which can only be observed by an eye of ever-shifting focus. And in painting, as in fiction, the single result of realism is falsity. When the novelist sets forth with his note-book you know that he will bring home a bundle of untruths. When he sticks to his fireside, he has a chance at least of inventing a probability: whereas, confronting the world with a hungry eye, he sees all things in a wrong relation, and the result is not truth but "copy." So too the conscientious painter grovels in the dust of superfluous veracity, and finds only a false effect. One inch of his

canvas may have some relation to nature. The whole
must ever be meaningless and void."

Idealism has been defined as the mental or intel-
lectual part, and it is held by many that a picture can
have no claim to art that does not contain its evidences
to a more or less degree, and that, although the " founda-
tion of all great work must be laid upon what is *real
and true*, the further development must be *mentally and
intellectually* conceived. Or, if the mental conception is
the first step in the process, it must work on to what is
evidently real and true."

Realism began as a protest against conventionalism,
and so far was useful, but it has now become a revolt
against beauty, nobility, and grandeur of style, and it
must be admitted that there are occasions when revolu-
tions are salutary. Perhaps, after all, ugliness may
have a useful qualifying effect on sweetness and affec-
tation ; at present it is itself one of the worst affecta-
tions of the century.

In a review of Mr. R. A. M. Stevenson's *Art of
Velasquez* (the same book noticed by another critic to
whom I am indebted for the definition of realism) in the
Spectator, a thoughtful writer gives the following defini-
tion of this little understood subject (misunderstood
because it was seized on by charlatans for their own
purposes). The real thing like good photography, has
been so overshadowed by the spurious and bad that it
has not often had a chance of being understood. I have
always opposed the imitations, and have consequently
been accused of opposing the theory itself, and am
therefore glad to be able to give a clear definition from
another pen than my own.

" Once the impressionist theory of vision and paint-
ing is grasped, it is easy out of various writers, even
out of Ruskin himself, to collect passages skirting it or

glancing at it. It is the doctrine that Reynolds attempted to state. It is what painter after painter has more or less consciously applied, without being in words able to express it clearly.

" The name has been much against the thing with those to whom it was only a word. ' Impressionism ' is a luckless enough term for a revolution in pictorial vision as radical as the introduction of chiaroscuro, of linear, or of aerial perspective. Inevitably it has been taken to mean hurried sketching. Now, a pre-Raphaelite may sketch hurriedly, but his sketch is not impressionistic, it is merely a hasty statement of his ordinary habit of vision. That habit is one of simple addition. If he has plenty of time he puts down 1, 2, 3, 4, 5, 6, 7. If he has less than half the time, he puts down 1, 2, and a bit of 3. This impressionist goes to work by summing these particulars before he puts down the result. He is therefore capable of a more rapid statement, but time is not of the essence of his procedure. His process of thought may take a longer time than the other's thoughtless enumeration. Nor, again, is a pre-Raphaelite picture made into an impressionist by blurring it over, as some have fondly imagined. (Painters will tell you that they do ' impressionist ' work *sometimes*.)

" Impressionism, then, does not mean hasty impression nor misty impression. It means *unity and order of impression gained by focussing the subject*. Just as linear perspective introduced a unifying natural action of the eye into painting, with one angle of view in place of a dozen, so does impressionism follow the natural eye, with one focus for a dozen.

" Focus affects the clearness of definition in two ways. If a number of objects, A, B, C, D, E, stand at different distances from the eye, and the eye rests upon

and adjusts itself to C, the nearer objects, A and B, and the farther objects, D and E, are thrown out of focus and are blurred. This may be called the *focus of distance*, and to represent two objects at different depths in a picture with the same clearness of definition is to puzzle and contradict the eye.

"But there is also the *focus of attention.* According as the eye selects one feature of a scene, or allows itself to wander more freely, the definition of the parts will alter; and, if we wish in a picture that it should be known what we were looking at, a not unreasonable desire, we must follow this procedure of the eye. If I look at A and B together, my attention is more diluted than when I look at one of them, and the definition of each is weaker—it is the pattern including the two that is defined. If I look at A directly, with B still there, but not attended to, the definition of B is fainter.

"So much for form. A similar law holds with regard to colour. The impressionist will not skin off all distance till his eye reaches a flayed local colour. He will fix with himself a distance that relates all local colours in a key. Nor will he scrutinise each patch of colour in turn with equal attention. If a yellow spot is focussed in a scene, all the other colours alter; if the eye leaves the yellow to play more freely, the yellow loses its insistence, and the *colour of the scene* asserts itself.

"It is only the unthinking who will accuse impressionism, thus understood, of being an easy slap-dash kind of painting. To appreciate the exactly right force of definition for the parts in relation to the whole is a task that employs the rarest faculties of vision, since to a sensitive eye a single false accent will destroy a whole picture. If it be argued that all this is a matter of mechanical and realistic rendering of facts, the assertion is manifestly untrue. Attention is governed by feeling,

every change in the definition of an object means a change in our emotion about it. Impressionism, in a word, employs the means of emphasis natural to vision. Other methods of emphasis there are, that of the decorative line, the silhouetted shape, the colour patch, and a painter may bind himself by the simpler conventions if he pleases ; but, if he does not comprehend impressionistic vision, he is not full-grown in the theory of his art, and is blind to its later history and triumphs."

A pure, unadulterated machine-made (man and instrument) photograph, if colour is allowed for, is the most perfect specimen of realism the world could produce; useful in a thousand ways, it would not be art any more than a minute catalogue of the facts of nature, however full of insight, is a poem. In early days we were surprised and delighted with a photograph, *as* a photograph, just because we had not hitherto conceived possible any definition or finish that approached Nature so closely, and here was something that actually had the effect of surpassing Nature on her own grounds. But we soon wanted something more. We got tired of the sameness of the exquisiteness of the photograph, and if it had nothing to say, if it was not a view, or a portrait of something or somebody, we cared less and less for it. Why ? Because the photograph told us everything about the facts of nature and left out the mystery. Now, however hard-headed a man may be, he cannot stand too many facts ; it is easy to get a surfeit of realities, and he wants a little mystification as a relief.

It has been denied that our art has sufficient plasticity to admit of modifications sufficient to enable a photographer to express himself in his material. We own it is limited, yet all arts have their limitations, and to be successful must work within them. There is this difficulty, however. The grammar and language of art

can be taught, but it is quite different with its poetry. Photographers want a formula for everything, but you cannot make a ten per cent. solution of idealism and give minute instructions how it is to be applied ; but I think it has often been very clearly shown that photographic pictorial effect depends entirely on the man, and that he is not limited to prosaic actuality. In some recent exhibitions there were sets of pictures shown, varying from the minutely defined to those of extreme diffusion, which could have come from no other hands and minds than those which produced them ; they were as individual as the works of the most mannered painters, and repre- sented not so much the subject which was before the camera as the photographer's individual impression of the subject.

Processes have been simplified, cameras have become more fearfully and wonderfully made, lenses have acquired a flatter field, and some of them can conjure a foreground out of the dim distance ; societies and conferences have multiplied, technique has, up to a certain point, improved, and all the world produces good photography ; many reach the dead level of excellence, but how few get beyond ! What a pity, in one sense, it is that we do not have more that contains the " little more " ; but, after all, it is good to know that there is something not easily reached still left in photography, and it also teaches that in our art, as in others, " the man's the man for a' that."

Clever writers are now discovering that it is not necessary that photography should make for realism, but, indeed, in its higher flights, may tend the other way. In an interesting article in a recent number of the *Nineteenth Century*, on " Realism of To-day," the author makes this interesting admission :—

" Perhaps one of the greatest enemies to the realism of the present day is the steady growth of photography.

After all, what can be more realistic than its manner of working? A flash and there is the figure in its most natural and real condition. Laughing, crying, winking, jumping, you can fancy you see the movement, and almost hear the speech. But does that satisfy the sitter or the artist, or is it not the main object and effort of both to beautify the production by soft and harmonious effects, to tone down and shade off defects, and so to produce an idealised beauty in the subject? And is not the result far more really true to nature than the inartistic and unaided pictures that marked the first years of the raw invention? If photography has discovered that in order to be real and true it must also be ideal, it is thereby teaching us a lesson which we may do well to profit by."

This is one of the most encouraging testimonials from the outside press that the " new movement " has received. It may, however, be said to refer only to re-touching, which all good artists condemn. But the sentence I have quoted refers not to a detail of practice, but to principle. It is not, however, retouching in itself that is condemnable, but the *bad* retouching, at present almost universal, which turns the human face divine into a semblance of marble busts or, still worse, turnips or apple dumplings. This is one of the instances of bad art which it is the mission of the new movement to correct.

The author of the article on Realism concludes as follows :—

" So we come back to where we began. To be real and true is the first great quality; but to conceive and superadd the highest possible ideal is also indis-pensable if we would ever hope to reach that perfection which is, indeed, in this world unknown, but which, in a world to come, may yet be found attainable."

CHAPTER X.

LIMITATIONS. THE NUDE.

ALTHOUGH I do not disagree with the principle expressed in the words, " Liberty for All," I know that liberty is all the better for a little restraint, and that it makes as much for progress to know what *not* to do as what to do. A brilliant flash of silence has been known to have more effect than most eloquent speech, and there is more artistic satisfaction in the simple breadth of a luminous twilight than in the noisy and multitudinous detail shown under the mid-day sun. Over-elaboration is a frequent destroyer, and a painting is sometimes at its best long before it is supposed to be finished. Art is to some extent suggestion. Occasionally, however, the highly finished reigns supreme, but it is by aid of other and greater qualities. It is possible to have too much performance to leave room for promise, and there is much poetry in promise. A few scratches of an etching needle may show more genius than an altar piece, though this great truth has been much depended upon and worked by charlatans.

Most excellent work is sometimes thrown away because bestowed on a wrong object, and, to come to our own art, very perfect photography is often wasted in a mistaken direction. Indeed, in photography it is becoming more and more a matter of serious study what to do and what not to do.

Admitting that there seems to be no bounds to the application of mechanical photography, there are many limitations to its artistic application that should be recognised and acknowledged.

Here is a quaint example. In a recent number of one of our favourite American photographic magazines, the author of an illustration excuses the badness of his picture by explaining that "the day was terribly hot, and the poor cow was tormented by legions of flies, and we found it impossible to get the composition we wanted." Now, surely the artist lost sight of several lawful limitations. The first was that the picture should not have been taken at all in such weather. A cow tormented by legions of flies should not have been selected as a subject for pictorial treatment; moreover, if the photographer cannot get the composition he wants, and he fails to realise his intention, he should not ask our acceptance of some inferior want of intention. In this case the photographer rightly gives the production up as a work of art, but he does not explain why the negative, which was not what he wanted, was not destroyed at once. I suppose not one in a hundred negatives survives its birth, but there is still nothing like enough destruction done. The negative to which I have referred was not all waste. Nothing is wasted in America. On the principle I suppose, that Providence brings nothing into the world without some good purpose —not even sugar-candy or the new developers—failing as art the photographer turns his negative to use, and concludes his explanation with the usual tag to American illustrations, an advertisement. " But it speaks well for C——'s plates with metol developer." Here ought to be another limitation. One of the things most calculated to knock all poetry out of a work of art is turning it into an advertisement of the material of which it is made, like a Mellin's baby.

Turning over the American magazines, we occasionally come to a lovely portrait or *genre* picture, and, of course, want to know the name of the picture and the

producer. For a long time the young lady sitter seemed to be christened, in very large letters, " Aristo " or " Ilo," or some such name, which showed a want of originality in the artists. Now she is " Somebody's Half-tone." Then the cows and sheep began to bear the same names, and further investigation showed that the names meant the paper or the plate used in their pro-duction. I am glad to see that the editor of at least one of the American papers, the *Photographic Times*, respects his art, and has given up the practice.

It is possible to get into two minds over the limita-tions of our art. On the one side I want all possible liberty ; on the other, I have a feeling that no artist, in whatever material, should transcend the bounds of the process which he has adopted. The end should be truly adapted to the means. " One of the most striking signs of the decay of art," says Goethe, "is when we see its separate provinces mixed up together. The arts themselves, as well as their varieties, are closely related to each other, and have a great tendency to unite, and even lose themselves in each other ; but herein lies the duty, the merit, the dignity of the true artist, that he knows how to separate that department in which he labours from the others, and, so far as may be, isolates it." However, it is not fettering liberty to endeavour to prevent one method or style competing with another, or to save ingenuity from taking false directions.

Taste has improved the world by limiting different materials to their own natural appearances—wall-paper, for instance, no longer pretends to be wood or marble— without limiting art, and I don't know that it is necessary for photography to look like the results of any other art. On the other hand, it need not insist on the brand of its calling ; there need be no insistance on its looking aggressively photographic. Each art should respect

its own individuality, but not worship it as a fetish.

Photography can only represent what is before it. If we are to accept this stereotyped saying, which we will for the moment, it helps to clear away and place outside our boundaries many things that are not worth sighing for, and better out of the way. It clears off all the past, the dead, and gone, and vanished. The true artist in all materials has still something of the " vision and faculty divine." Much is denied to us in poetry, history, and legend—we are not allowed to guess and call it true, as the painter is, but we have plenty left, and shall have more when we have eyes to see. But the photographer should always keep in mind that, if, in the nature of things, he is bound to have his object before him, he is not bound to see it as others see it. Indeed I do not think any two photographers can see or represent precisely alike. Individuality is bound to come in, and a very little variation seems to make all the difference. There is that curious instance, which will be a precedent, in a late Pall Mall Exhibition of two pictures of the same subject, under similar conditions, of nearly the same size, hung close together, the only serious difference seeming to be in the title ; yet the judges were able to detect a variation—some subtle poetic aroma, perhaps— in one of them which made it worthy of a medal, and the other unworthy.

It is the business of the artist to see beautifully, and to show men what they might see if they also were artists.

But, whatever limitations we may find prudent in our practice, we shall allow none to its possibilities. We should use our limitations only for convenience and to simplify our work. Within ordinary bounds, the art has much more flexibility in its technique than some critics

will allow themselves to believe ; and the limitations
science would impose upon it have done much to retard
the true interests of photography, except as a handmaid
to other arts and many trades.

What is it that suggests that some remarks on the
nude in photography would be in place here ? Ought it
to be one of our limitations, or would that demand be
too narrow ?

In the present age and condition of the world, the
nude in photography is an anachronism, except in the
uncivilised portions thereof. The nude still exists
among savages who have not yet been civilised out of
their taste for the manners and customs of Paradise as
we are taught they existed ; but it does not seem up to
date for young gentlemen to walk about undressed, and
for young women with wasp-like waists and distorted
toes to disport themselves " mit nodings on." The nude
and the undressed are different things ; these figures
would be not so much nude as undressed. To some
people this would mean the same thing, but " oh, the
difference ! " I do not say this out of any consideration
or respect for Mrs. Grundy or her tribe, it is a matter of
art. The nude is the divine ideal; the undressed is the
modern naked girl, and, like the angel with the vicar,
she makes no apology for her impossibility ; and, as I
have suggested before, the impossible is an established
limitation.

The nude has no excuse if not beautiful ; the modern
nude is not beautiful. If many people were asked what
was the most beautiful thing in the world, they would
say without hesitation the Venus of Milo ; the other end
of the scale is the modern model for what Trilby calls
"the altogether." The least touch of imperfection in the
form, or awkwardness of motion, and down comes the
ideal to earth, and it is of the earth, earthy.

There is too much realism in the photographic nude. The nude belongs to poetic art, and in this, above all, we must accept strong conventions. The object is not nakedness, but an opportunity for the display of graceful lines and forms, delicate shades, and gradations ; the subject must be many planes above reality. Absolute realism never succeeds in any art. Effort is now being made to introduce " real conversation " on the stage ; but it only succeeds—if, indeed, it does succeed—in afternoon-tea comedy. The poetic drama must be in verse of some kind ; so also must the nude be idealised, and who can idealise a modern waist or a distorted foot —or, indeed, any human form marred by artificial devices ? It has been wisely said that the ideal is the blossom of the tree, realisation is its fruit—and sometimes the fruit sets the teeth on edge.

The only excuse then for the nude, is beauty, to which may be added the skill with which it is executed in line or colour. It is too late for a photographer to claim credit for any great amount of beauty of execution; there is no opportunity of showing beauty of colour, and beauty of line is handicapped by want of beautiful models. Fashion has destroyed nature here. What it has done is clearly explained in the familiar punning verse :—

> " It matters not, though doctors may
> Declare that it will kill,
> The awful corset's here to-day,
> And stay of corset will."

Moreover, if perfect models were possible to make the nude in photography acceptable, we should want the universal artistic refinement of the ancient Greek, or the indifference of the savage. We hold a middle place, our cultivation is too artificial.

Just a final word. It comes as a matter of course for some people to say " studies of the nude would be so

useful to the artist," meaning the painter or sculptor ;
meaning those who ought to be quite competent to paint
or model for themselves. For my part I would no more
offer to design his work for the painter, than I would to
finish his picture for him—however much I could see it
wanted it. The more the painter does without "outside
help " the better; the better for his picture, himself, and
pictorial honesty and morality. That a vast quantity of
valuable property of this kind is appropriated is certain,
but this kind of flat burglary is becoming more dangerous
daily, particularly when the delinquent takes Oliver
Cromwell's advice, and copies " warts and all " on the
tiger's nose. Then the copyist gives himself away, and
if there is a Gambier Bolton about, he who " takes what
isn't his'n " is found out and has to pay.

CHAPTER XI.

FALSE PURITY.

" Wisdom in extremes is folly ;
truth, when carried to excess,
ends in wisdom written backwards."

IBSEN (" Pier Gynt ").

THESE lines are by the famous modern dramatic poet who follows Nature so slavishly as to give no evidence of art whatever in his works. Truth to Nature will not allow him to use capital letters at the beginning of his lines, as other poets do, yet it is an un-expected relief to find that even he, the extreme realist, feels and admits that truth in excess is wisdom written backwards. This applies to photography as much as to any other form of art.

That good art must be based on truth to Nature is admitted by the most conventional, but the word " truth " has become a kind of automatic cry little under-stood by many who use it.

The aim and end of the artist is not truth exactly, much less fact ; it is effect.

I know this sounds shocking to the purist's ear, but it is quite true. There is no doubt he best gets his effect by way of truth, but he uses it as he would a servant, not as a master. The newest critics go so far as to say that effect is not only the aim but the end of art, and will not admit that it need say anything more. It is not good to set up a fetish, even a respectable one. Truth should be classed with the other materials, whether paint, brushes, canvas, cameras, or prepared plates. All must, of course, be properly used or success

F

will be missed, and the greater the ambition the more prodigious the fall if failure ensues, which is as it should be. Fortunately the photographer has always the opportunity of destroying his failures, a privilege, however, of which he seldom takes sufficient advantage.

Besides the truthful ones, there are those who honestly have a holy horror of anything they do not think legitimate in photography, but there are more who only pose as strict and proper professors of our gentle art. The standard of what is right is, however, often of their own setting up, and a false one. What is our art that it should be more strictly guarded than any other? There are proverbially tricks in all trades, and why should we not have some in ours? This affectation of pure photography is like talking of the " well of English undefiled," of a language that is more than half foreign and the rest American. In painting I have seen the wet paint of a stone wall mixed with sand to give texture, and the effect applauded by the most righteous; but by the same people, in photography a little " doctoring " is considered extremely wicked. Now retouching is extremely wicked indeed, and I strongly condemn it myself, not, however, because a little handwork is added to the film, but because it is so often overdone, and so seldom done well. It is blundering that hurts.

Then, again, there is the amiable enthusiast who is quite sure that no good ever has, can, or will come out of anything but purely scientific photography, and proudly boasts, as though it were exceedingly meritorious, that he knows nothing of art. This, however, does not prevent him passing opinions on purely artistic subjects. Combination printing is one of the artistic means that cause him to almost shake his head off as most impure. He does not look at results except for evidence of his theory. We all admit that when two or more negatives

are used in one picture, in unskilful hands the result may be incongruous ; but his scientific deduction from this acknowledged fact is that anything that has the chance of going wrong always goes wrong. The last comic scientific writer on the subject gravely asserts that he sees " several curvetting suns " in every combination photograph. This has the merit of candour ; a sublime height of honest confession, which is good for the soul when you have one, that few could reach ; but the only deduction I can draw is that he ought to be ashamed to admit it !

What must be the standard of legitimacy set up by these purists ? A complete discussion of the subject would take us into the middle of next year. The negative, we know, must be produced by purely photographic means and left in its raw state, but that is only the surface of the subject. What lens may be used and what angle included ? May a portrait be taken with a landscape lens, or the reverse? Is a rapid rectilinear or a doublet a landscape or a portrait lens ? I confess to using one of these for both purposes, and expect, now I have confessed it, to have it found out by the critics. Would it be a departure from the truth as it is in photographic purity to reduce or intensify, or to varnish the negative, and, if the negative is weak, may a little colour be introduced into the varnish to improve the printing quality, or may it be printed under ground glass ? When once we go in for rigid purity in any art we must be careful what we are about. There is another little operation that some of us do by stealth. We are sometimes so depraved as to sun down parts of our prints to improve the much maligned artistic effect. It may well be called by some operators " blushing " ! I suppose this nefarious proceeding puts us completely out of court. The mention of this useful operation reminds me of an

anecdote of Rejlander, and I cannot help falling into an illustrative digression.

Once upon a time, now almost forgotten, in the golden age in fact, when some of us quarrelled and fought over photography, and esteemed each other all the more ; when we

"Strove mightily, but ate and drank as friends " :

when men worked for the art more than their own hand ; when there was something to learn, even in the technical part, for it was in the days of the wet process, there was a grand attack on combination printing, led by a writer who was not ashamed of having some knowledge of art. Rejlander was never very useful with the pen, but he had always a quaint fancy at the service of his friends. His contribution to the subject was a picture of pure photographic art, without even a negative to intervene and sully the purity. Nothing, I think, has ever been said on " The Pinhole as a Printer," a subject that is open to discussion. Rejlander used the pinhole for this purpose. He bored a hole with a bradawl in a piece of cardboard, and allowing the sun to shine through it on to a sheet of sensitive paper, used this bundle of rays as his pencil. Moving the cardboard with the hole about, here a line, there a shade, using a smaller hole for the more defined parts, the artist soon produced his work of pure photographic art. It represented a donkey, on whose side was marked the initials of one of our opponents. This picture was toned, fixed, mounted, framed, sent to the exhibition, and, I believe, rejected as frivolous—a precedent that has not been much followed in recent years. And nobody enjoyed the joke more than our friendly opponent—another precedent which is no longer followed.

Now to return to our scientific disabilities. May we use a swing-back, or is this invisibly distorting but most

useful arrangement to be denied to us? To go into what is legitimate in printing would lead us into a maze of unorthodox proceedings, to do without which would leave us more than half starved. The scientific allowances to the photographer remind us of Sancho Panza's dinner in Barataria, when he was allowed nothing to eat because everything would disagree with him. The pure photograph would be an actinometer-made article. So correct, so true, so unlike the spirit of Nature, such an artistic lie! Yet how many lose the spirit in looking after the form, and give us in their pictures only the dry bones of Nature,

" Bare, bald, and tawdry as a finger'd moth."

A word or two above suggests the question, Why should scientists take such pleasure, as they seem to do, in denying that they know anything about art?

There is a fashion in all things. Not only in our material wants, but in our ways of thought and mode of expressing them. For many years everybody professed to know everything about art, and felt ashamed of the ignorance they always tried to hide; others read up so as to enable them to assume a virtue and be dictatorial on the subject; but now it is quite the correct thing with many people, chiefly scientific, to boast that they "know nothing about art," and seem to be absurdly proud of their ignorance. This must be a cruel blow to South Kensington and the promoters of museums and art schools. And it is a very sad thing that in many cases we cannot help feeling that the scientists, in this matter anyway, have found truth at last.

How is this denial of a knowledge of art to be accounted for? I think I have it. Blake said, " Every man is a judge of art who has not been connoisseured out of his senses," and, perhaps, that is what is the matter. The artists, with the best intentions, have been

supplying the scientists with more good food than their feeble digestions could stand, and of a quality they could not assimilate. It should be our agreeable duty, in future, to prevent them from playing with what they confess they do not understand.

CHAPTER XII.

THE QUESTION OF FOCUS.

THERE has been so much written on this subject
that I scarcely know how to get in a word. I
have certainly nothing new to say, but as this question
has called attention to, and caused discussion on,
pictorial photography, some notice of it must not be
omitted here.

The theory of art that was known as, and oddly
named Realistic Painting, and its offshoot, Realistic
Photography, is now superseded by the much more
reasonable theory termed Impressionism, of which I gave
a definition in the last chapter.

The fact that the eye could not see everything all at
once is of course not a new discovery, but that the eye
should not be allowed to ramble while looking at nature
undoubtedly was. Given a new thing with perhaps
" something in it," or out of which something mysterious
may be made, and exaggeration even to absurdity is
almost sure to follow. Hence a good deal of the ill-
directed rubbish with which we have been mystified.
In the theory itself there is much that is good. All
movements of the kind attract men who in default of
talent must find some other means of attracting attention,
thus good things are often brought into disrepute by
those who pretend to support them. However this may
be, impressionism has induced the study of what we see,
and shown us that we all see differently; it has done
good to photography by showing that we should
represent what we see, and not what the lens sees. I
think we have here the kernel of the nut. The struggle

is now to see pictorially and to represent pictorially. There is the rub.

What do we see when we go to nature? We see exactly what we are trained to see, and, if we are lucky, perhaps a little more, but not much. Does the agricultural labourer, for instance, get any æsthetic pleasure from a thunderstorm? Yet his feeling may be strongly moved by " a niceish bit o' muck." I doubt if he ever sees the sky except as the source of wet or dry weather as it may affect his work.

The artist sees the forms, masses, and colour of nature, the scientist looks under the surface and rejoices in facts. Art feels and enjoys; science vivisects and calls hard names. We see what we are prepared to see, and on that I base a theory that we should be very careful what we learn. I shall always regret allowing myself, many years ago, to read a book on the theory of colour, which dissected the rainbow and made the plainest prose of the bluest sky. I shall never really and truly *see* colour any more. I shall never revel again in a delightful, sensuous love of colour; my mind involuntarily runs on what rays are absorbed, and what reflected. It is a melancholy satisfaction to know that this dreadful book is an example of the uncertainty of cocksure science, and is now to a great extent discredited or superseded by other " sure enough " theories.

Science removes illusions and substitutes hard facts; are we the better for them? It is an illustration of Hood's fine lines in " I remember," when the man had lost the boyish ignorance that the treetops touched the sky.

" Now 'tis little joy
To know I'm farther off from Heav'n
Than when I was a boy."

About twenty-five years ago several photographers, of whom the present writer was one, who were devoted

to the practice of picture-making by photography, began
to agitate for lenses giving a softer image and more
diffusion of focus. Fully recognizing that the lenses as
then made, giving optically perfect focus, gave images
sharper in one plane than could be seen with the eye,
and confusion and blurring in other planes, they induced
the late J. H. Dallmeyer to make a lens that would
distribute the focus and give them what is called depth
of focus. This lens was followed by the Rapid Rectili-
near as we have it now. It has been recognized, then,
for many years that too much sharpness and definition
was possible.

Notwithstanding that some few photographers had
seen the value of softening the focus for many years,
there is no doubt that the science-taught photographic
world was given over to brilliant sharpness, and the very
absurdity of some of the earliest examples of purposely
out-of-focus photographs did good by attracting more
marked attention and causing energetic discussion.
Though not believing in and opposing Naturalistic
Photography, I said at the time " good may come of a
reaction against that excessive sharpness of focus, which
is still dear to the amateur and professional alike, and
against which photographers who practise art have
always protested." Although the recent great advance
in pictorial photography is due mainly to other causes,
there is no doubt that Mr. Francis Bate's book on
" Naturalistic Painting " had something to do with it,
although the theory differs greatly from Impressionism.
This being the fact we may as well have a word or two
on the subject here.

This school of painters originated in France in
imitation afar off of our own John Constable. They
scorn all the teachings of the past, and profess to imitate
nature closely ; but they do it according to theories of

their own, which do not commend themselves to the great body of artists. They disclaim against conventional rules, but set up a convention of their own.

After deciding that the " confines of conventional rules " must be broken down, the first principle of their art seems to be that nature must be represented as the scene first represents itself to the eye—the first impression. And they have peculiar ideas of what the eye really does see. It is thus given by Mr. Francis Bate in his book on the subject: " There is this undeniable truth occupying an unassailable position in the art of picture-making, viz., that the interest of different objects is relative, just as their tone is shown to be relative ; that the detail is to be most fully realised in those objects which are nearest to the centre of vision of the picture, and nearest to the spectator at the same time. This is no conventional recipe, but a natural law governed by, and explained in, the science of optics. It is upon this law that our impressions of nature are greatly dependent. Wherever and in whatever direction we may look, our vision centres itself in one point, called the centre of vision. Some objects near and around the centre of vision we may see very distinctly ; others, not so near, are seen less distinctly ; others again, still further from the centre of vision, are seen very indistinctly, until outside the circumference of the base of the cone of visual rays all things are blurred quickly, and we see nothing. In one glance, unvarying in direction, we have one centre of vision in our impression of nature."

The difficulty is, that this is not an " undeniable truth," but is explained quite the other way by the science of optics. The fallacy consists in the fact that the eye is *not* a fixed instrument ; and if the picture is to represent more than a very momentary first impression

indeed, as pictures always do if the eye be given time to see, a great deal more will be seen than the centre of vision. This keystone removed, away goes the whole structure. On the other side, it is held that art must represent what the eye does or could see, and recognizes that it changes its focus so as to adapt itself to every plane so instantaneously that we practically see the whole of a scene in focus at the same time.

The result is that photographs in the hands of artists are, as a rule, more pictorial than they have hitherto been, except in very few hands, and that in at least one of our exhibitions—The Salon—mental has been set up over mechanical photography. The burlesque effects of out-of-focus photographs, if they are exhibited at all, are shewn as awful examples; on the other hand it is not easy to find an exhibited photograph in which extreme focus is present.

In one of his works, Helmholz admits that the eye is an imperfect optical instrument, and adds that if such an instrument was sent to him by an optician he should feel justified in rejecting it. Herein he would have differed from me. Feeling sure the optician ought to know his business better than I did, I should have used that instrument and not cried out before I was hurt. Mankind has been perfectly satisfied for many thousands of years that its eyes were " adequate anyhow," and it is very unkind of science to point out the defects. And who knows if our opticians, imitating nature more exactly—as it is the fashion to demand—put a " blind spot" into their lenses, they would not be better for it?

CHAPTER XIII.

MODELS.

I SOMETIMES think that photography suffers more from photographers, or those who call themselves photographers, than from any other class. We call photography very easy, and so it is up to a certain point, but anything beyond that point seems to very many to be unattainable. There are some who do not know how easy it is to fail because they never try to succeed. Others see a photographer who has been studying his art for years succeed in producing a certain effect, and do not find how difficult it is until they have made many vain efforts. Then they give it up and resort to the ingenious device of exercising their flippant pens in endeavouring to persuade all other photographers that the particular effect, or method of producing it, ought never to have been made at all, another illustration of Æsop's immortal fable. This has been very conspicuous in the case of combination printing as a method, and the use of trained models as figures in landscape as an effect. We will leave the method alone at present and turn to the effect.

Many things have combined to militate against the use of trained models in photography. One has been ridicule, an excellent weapon against abuses, but a very dangerous one in unscrupulous hands against legitimate uses. Some years ago I was foolish enough, hoping to encourage the picturesque in our art, to explain how I got my models, dressed them, and used them, just as another would give you the formula for his developer. This was a fatal indiscretion. Frank confidence, except about things that can be weighed and measured, does not do in photography. Instead of giving a useful lesson you play into the hands of those whose interest it may be to discourage a journey in a direction they could not themselves follow. Up to a certain time the combination of grace and rustic naturalness in my figures was admired, and I was envied the "luck" that always seemed to supply me with the right figures just precisely when I wanted them. But when I showed how it was done, how the result was achieved by a combination of intelligence and strict adherence to the *appearance* of nature in the models, and common sense and some knowledge of art, as well as power to invent a subject, in the photographer—all of which aids are necessary— unenthusiastic photographers felt discouraged at being asked so much, and finding that they had few of these necessary qualifications to fall back upon, resorted to the ingenious device of condemning figures in landscape altogether, and my "young ladies" have never since been forgiven. Only a few months ago a photographer, who has achieved a sort of reputation for eccentricity, but has never produced a picture, took the opportunity of dragging into a paper he read, reference to "those mongrel-attired ladies who would be more comfortable with sunshades instead of the staring sun-bonnets they affect for the benefit of the camera man."

The moral of all this is that it is a fatal mistake to let the sawdust out of the puppet if you want it to dance. It also means, but chiefly for your own satisfaction, that in models nature must be exactly imitated.

Much mischief has, I acknowledge, been done by use of the dressed-up figure, but it has not been by the fact of figures being used, so much as by the incom-

Fig. 1.

petence or carelessness of the photographers mismanaging them. For instance, we usually find that when a young lady is dressed as a peasant model she generally looks like one of the chorus in an opera. The clothes are new and very clean, the country clodhopping boots are perhaps represented by patent leather shoes, and by some strange dispensation of artistic providence she is only allowed to appear as a milkmaid or gleaner. This,

I repeat, is the result of incompetence not of method, the false artist not the art.

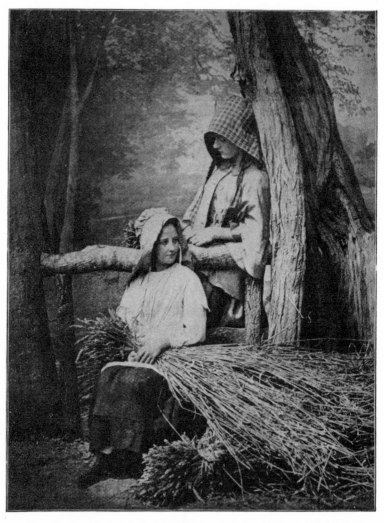

Fig. 2.

My method differed somewhat from this. I certainly often employed a young lady model, but I was careful in the selection to take only those who were fitted in

face and figure for the scene to be represented, and that they were near enough to be possible (which is all that art demands), is proved by the fact that they were not only

Fig. 3.

never detected by critics of the pictures until I foolishly pointed out how they were done, but that the models were often mistaken for the genuine article by the natives themselves, as was shown by many curious adventures.

G

One most important point is that the clothes worn by the models should not be new. In my practice I always used *old* clothes. These were obtained at first hand from the original wearers. Once upon a time, when I was doing more of this kind of work than I am now, I did a great trade in the exchange of new clothes for old, and I still possess a collection of garments and accessories bought in the villages as occasion happened, often at the expense of a vast amount of trouble and diplomacy.

With a well-trained model, always supposing you do your work properly, you can get nearer to nature *than nature herself.* This seems a bold saying, but is quite true. Besides being extremely difficult to manage, very awkward and self-conscious, it is not easy to explain what you want to a fresh caught peasant. Sometimes she is superstitiously afraid of being photographed, at other times she remembers having been told to " keep quite still "—words that have spoilt many a photograph — and becomes another being, rigidity taking possession of her, or if you don't allow her to go home and put on her best clothes she will probably not let you take her at all. A model of this sort is not worth wasting time over.

I have mentioned that with an intelligent model and knowledge you can get nearer to nature than nature herself, and I should like to emphasize this statement. I don't say it of bad art, but in good art in any material the result is usually finer and more natural than is to be seen in any snap-shot work from unconscious figures. Some of the most beautiful things in photography are to be got with the hand-camera, but it is not when used as a detective or a " without-knowing " camera. How very rare is it that we see a street scene, or any scene containing numerous figures, that does not belong to

that deplorable class, "might-have-beens?" There is
sure to be some awkward figure which spoils the—it

Fig. 4.

would be gross flattery to call it a group. Nature, or
what we are pleased to call nature, is never at her
best, and heterogeneous arrangements are seldom

satisfactory. Moreover, there is another considera-
tion.

England is no longer the picturesque country I
remember it so lately as thirty or forty years ago. It is
beautiful still, but marred by discords. Of course the
most fatal gash on the beauty of the country is one that
is ruining the appearance of the whole earth—I mean
telephone and telegraph wires—but there are two other
causes that rob us of much material for pictures : the
introduction of machinery in agriculture, and board
schools. The lusty mower or reaper is no longer to be
found ; it is only in very remote districts that we now see

> "A meadow gem-like chased
> In the brown wild, and mowers mowing in it."

The gleaner, chief feature in past rural scenes, whether
in literature or art, is now no more ; the smock-frock
and sun-bonnet are seldom seen near towns ; children
have been converted by compulsory education into primly
dressed little prigs; the lovely, wild-flower-bespangled
hedgerows have been trimmed ; the " nasty violet," as
the huntsman who preferred a different scent called it,
scarcely exists now as a wild flower, and the primrose is
following. Yet I do not notice that agriculture is in any
better condition, or the people more content.

The worst models are theatrical people, often con-
sidered to be the best. It may be put thus : actors are
the best models for *bad* photographers and the worst for
good ones. The reason is this : a bad photographer
cannot make a picture, and if he must have pictures
instead of trying some other business, it would be well
to get somebody to make them for him. An actor may
do this, the technical part of the matter being easy to
almost anybody in this technical age. On the other
hand, the photographer who is an artist has ideas of his
own, and he wants obedience in his models, some

intelligence, but no other help. The lower classes are
often picturesque, but too often too stupid to understand

Fig. 5.

what is required, or they are board-school trained, wash
themselves, and help you past endurance. The actor's
chief fault is too much emphasis; it is part of his art,

which seems to require more "damnable faces," as Shakespeare calls them, than any other.

So that the required effect is gained and a good picture is produced, I do not see that it matters how it was produced. Whether the body inside the clothes belonged to the upper or lower classes, even whether he, she, or it was alive or dead. The effect should be so good as not to recall the means. Do we insist that a modern picture of Cleopatra should be painted from a real live queen ? The poet says, in default of the real thing,

"'Tis from a handmaid we must paint our Helen."

Surely, then, a photographer may be allowed to take every advantage when he strives to combine the best effect with the nearest approach to nature.

It may, perhaps, give a little interest to this chapter if I introduce a few of my models, not always in their habits as they lived, but as they appeared to me. To begin with the initial figure. I should like the candid opinion of the reader whether this one is artificial or natural. Is it Mr. Briant's "mongrel-attired lady," or "Mrs. 'Enery 'Awkins"; wax model or Dutch dolly ?

Fig. 1 is a very early example—1858. She was a fine healthy girl of about fourteen, and the picture was done to see how near death she could be made to look. The question of the time was whether idealization in photography was possible. It is usual now to call everything that does not suggest any other title "a study," when, perhaps, there was no real study about it. This picture was really done for the purposes of study, and may be called one. It afterwards developed into a large picture known as "Fading Away," which shows that the design of a photographer can grow—a fact often denied by critics who depend on their own slender knowledge.

Fig. 2. I am sorry I have not a contrasting picture in robust health, as she was at the time. She appears

Fig 6.

in this illustration, however, three years afterwards. She was one of the best models I ever had, and had the rare merit of never making the slightest suggestion.

The younger girl was a charming little model who appeared in several of my pictures many years ago.

Fig. 3. This is an example of a picturesque model caught wild, but too stupid to be of any use. Naturally she had a delightful smile, and although I tried all I knew for a fortnight to overcome her timidity—mixed her with tame models, as they train wild elephants—she remained camera-shy, and I could do nothing with her. I did the next best thing. I bought her clothes.

Fig. 4. A Mountain Dew Girl, from the Gap of Dunloe, Killarney, Ireland. All that is visible is genuine nature, except the face and hands, which in unadulterated nature were quite too repulsive, except for impressionist painters of music-hall scenes and coster horrors.

Fig. 5. A study for a figure in a large composition. In the finished picture the old lady is listening to a reader. This is apparently a very simple subject, but I found it necessary to take eight or ten large negatives before I was satisfied with the listening look. This was not the negative employed.

Fig. 6. Group on the shore. Although these are genuine fisher-folk they are by no means accidental models. The two old men had had much practice in sitting to painters, and knew how to obey.

The illustration on opposite page (fig. 7) is a mixed group, and I leave it to the critic to point out which is the real and which the ideal.

Fig. 7.

CHAPTER XIV.

FOREGROUNDS.

IN a landscape by whatever means, but in photo-
graphy more particularly, the foreground is usually
a very important part of the picture. Why the fore-
ground should be thought of more consequence in a
photograph than in a painting is not far to seek. In
painting the artist has more command than the photo-
grapher over his effect in representing the more
distant parts of his subject; he can perform the function
of faith and remove mountains; he can build castles or
temples just as the fancy takes him to be gothic or
classical; he can divert the course of rivers; he can
destroy or he can build up, but he cannot, without very
great labour and pre-Raphaelite skill, rival the sun
artist in his power of representing foreground detail, and
as it is natural that all means of art should tend toward
the kind of production for which it is most fitted, it
follows that, however it may show its varied powers in
other directions, photography almost insensibly gravitates
toward the kind of effect which shows its peculiar powers
to best advantage. In saying this I must not be mis-
understood to infer that because a lens can always secure
detail that detail is always worth securing. On the
contrary, sharpness, as its name implies, is an edged
tool, very useful in skilful hands, but if not used with
caution, dangerous and sure to wound; and indeed it
has caused much mischief in pictorial photography.

Another reason why the photographer should value
the foreground is that it is more within his reach than
other parts, and offers him greater facilities for correct-

ing his composition. It is also valuable as giving him the power of showing that his picture was not one of nature's flukes, and that the artist had more to do with the tune than merely turning the handle, whether the music was good or bad.

It is not every subject that has a picturesque or suitable foreground ready made. We often meet with a scene that would make a fine picture if it were not for the bald, uninteresting foreground, the level meadow, or

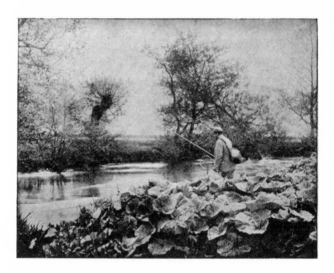

Fig. 1.

the dusty, dreary road; but it is often within the power of the ingenious photographer to do well with un-promising materials. In selecting a subject we choose that standpoint which brings into prominence its most interesting feature, or it may happen that we add the leading attraction for the eye in the shape of a group of figures; in either case we try to subordinate all the rest to the principal object. A very little variation in the point of view may make all the difference. We may

hide the ugly and give prominence to the beautiful, introduce new beauties, or increase breadth of effect by possibly a movement to be measured by feet or inches. Blank spaces or flat foregrounds may often be improved by the long shadows of evening, or by the introduction of figures, and much may be done in some cases by the judicious use of the pruning hook. If the scene be the chief consideration, the figures must be kept subordinate, but it is becoming usual among painters to make figures

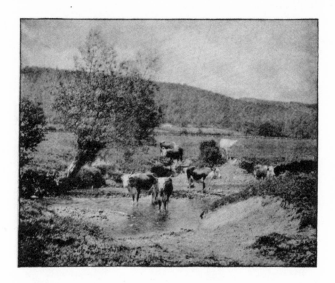

Fig. 2.

of more importance in their landscapes. One of my illustrations to Chapter VI. shows how rather large figures may be sometimes used.

It is really wonderful how much may be done by very little if done judiciously. A small spot of white or black, and occasionally of both, may turn a poor subject into a very presentable picture. The spot, for pictorial purposes, may consist of anything, but preferably it should add interest to the subject.

It would be useless to go into details as to the arrangement of various kinds of foregrounds. The student should study the general laws of art, and with their aid, and the common sense and quick perception without which no photographer can hope for the highest success, he will be able to deal with each case as it arises, remembering that the more simple the subject and broad the effect, within limits, the better.

By way of illustration I have selected a few pictures

Fig. 3.

that owe a good deal of their effect to, and would not be pictorially complete without, their foregrounds, all of which owe something to the hand or head of the photographer.

Fig. 1 is a river scene in which the foreground consists of a mass of large-leaved plants, full of the most minute detail, yet the mass forms as a whole a breadth of light, contrasting and sending back the slightly less made out middle distance. In this case the plants are

interesting as being the largest leaved indigenous plants we have and are only met with in certain parts of the country. Pictorially the foreground was the motive of the picture.

Fig. 2, an example of a circular foreground. The banks rise on either side and partly frame in the cows. The banks form agreeable lines and contrast the horizontal lines of the meadows, the shade on the left being well opposed to the mass of light on the right.

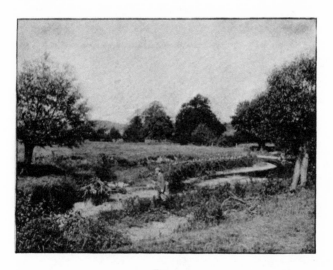

Fig. 4.

Fig. 3 was originally a negative of a boat and a beautifully composed bit of sea, with an awkward line of beach utterly useless as an exhibitable picture. The crab-baskets and the whole of the foreground were added from a second negative.

Fig. 4 contains splendid material for a picture, yet is a frightful example of what not to do, showing that nature without art is not enough. The light is behind the camera, making the landscape as flat as the pro-

verbial pancake. The figure, well posed, so that there should be no room for fault on that score, is in pictorially the worst place, but naturally, for fishing purposes, the best. It is not only exactly midway between the sides, but also between the horizon and the base line. There is no atmosphere and no sky ; the photographic technics would I believe be considered perfect ; the image is very sharp and very clean. Let me be allowed to hope that none of my readers ever did anything, however technically commendable, so very bad, so very " natural."

CHAPTER XV.

THE SKY.

THE sky is the crown and glory of the landscape, it
is capable of all varieties of expression, from the
smiling cirrus to the inky frown of the storm cloud;
nothing in nature is more conducive to pictorial effect;
nothing so helpful for saving a p cture that has not quite
enough in itself; nothing so easy to photograph, and yet
we not only do not give it the attention it deserves, but
treat it with indifference and neglect.

We have the sky always before us, therefore we do
not recognise how beautiful it is. It is very rare to see
anybody go into raptures over the wonders of the sky,
yet of all that goes on in the whole world there is
nothing to approach it for variety, beauty, grandeur,
and serenity.

The sky is also very obliging. It will make a
picture of itself, or it will fill up a corner, and supply
you with almost any form, or light or shade you may
desire to complete your composition. In many cases it
allows itself to be captured with your foreground, in
others it gives you the option of almost unlimited
selection.

As I have said, there is nothing easier to photo-
graph than the sky. The mechanical details are indeed
so simple as to leave little to describe. Theoretically I
should employ slow isochromatic plates, colour screens,
special developers; as a matter of fact I do nothing of
the sort. Some of the best skies I ever got were with a
hand-camera, smallest stop, quickest exposure marked
$\frac{1}{100}$, quick plates; and the handiest developer being

H

pyro-ammonia, I used it. All very wrong, the experi-
menters will tell me, but I pleased myself, also very
wrong, no doubt, and a gross of plates returned nearly a
gross of useful negatives, which are now sorted into
boxes according to the time of day, direction of the light,
etc., ready to be selected from as occasion may arise.

The print, Fig. 1, is one of the batch. This is a
picture which the learned attribute to combination

Fig. 1.

printing ; I do not want to undeceive them, but I give
it here as an example of what can be done on one plate,
at one snap. The one thing to avoid is any trusting to
accident. I am sometimes congratulated on my luck,
yet nearly my whole photographic creed is that the
chapter of accidents is one of the most unreliable in the
bible of the foolish. A dozen negatives of skies and
seas with gulls, all more or less well composed, were
taken within an hour after this little picture was done.

The two gulls did not dawn upon me for the first time when I developed the plate, as a lucky chance would have done ; the birds were seen afar off coming in the right direction ; the yacht's course was altered so as to get broadside on them, and the pace made approximately even so as to lessen the fear of blur. In rapid movement to run alongside your object gives you opportunity of a longer exposure than if you stood still, always supposing your movement to be smooth. No negative of the dozen

Fig 2.

was spoilt by the movement of the gulls, neither, I think, are they so sharp as to appear frozen, or hung on wires. Pictures of this kind are so easy that I wonder they are not oftener attempted. Perhaps they do not give rise to sufficient mechanical ingenuity in the novice.

I have said don't *trust* to accident, but I would not *refuse* happy chance if it offered. The chance, however, should be of my own making, if possible. There is a good deal of playfulness and freedom in accident which, in art, is sometimes a good substitute for skill.

It is in rescuing a picture from mediocrity that the sky is so clever.

In considering whether your print requires the addition of some sky it is no use saying, "Oh! it is only

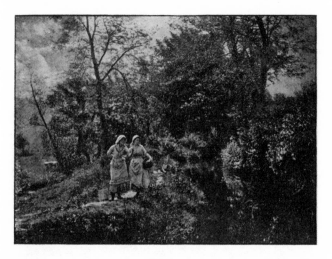

Fig. 3.

a little bit, that don't matter." A small bit of light or dark will make or mar a picture. Even the little spaces that peep through trees in woody scenes should not be left blank. The gradation given by a background of cloudy sky gives a completion that could not otherwise be obtained.

It is not necessary here to go into the usual arguments that the obvious facts of nature must be observed, the sky and landscape harmonised, and lighted from the same source, and all the rest of it that ought to be obvious to anybody, but I may call attention to a very singular fact. If we may believe the usual tendency of criticism no photographers have sense enough to use a sky properly, but all photographers who never use skies are capable of discovering the mistakes

made—and the joy of pointing them out transcends any delight to be got out of any photograph, however beautiful.

Many a crude result may be turned into a success if the operator would try to understand, and act on the knowledge, that in almost every case a raw print of a raw negative is not fit to show as an example of what can be done to represent beautiful nature by our art, and if the artist would begin where the chemist left off, or, rather, would do more toward depicting the beauties he ought to see in nature, but which are usually unnoticed by the unsympathetic camera; if the photographer would educate his eye to see nature as it is, and not be so ready to believe what the scientific photographer represents as facts, we should soon discover a

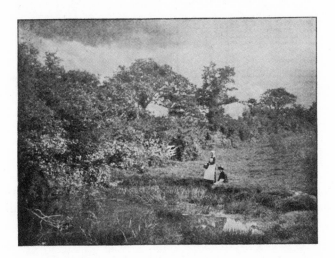

Fig. 4

vast improvement in landscape photography. This matter of the sky is a case in point. The plain, unblushing photograph, the machine made article, usually represents an ordinary landscape as being

backed by a plain white paper sky, and I am not sure
that reproduction does not sometimes intensify this
effect. Now, white paper represents nothing in this
world except a plain space of unsuggestive blankness,
and, on the other hand, not one inch of the space it is
supposed to represent in a photograph is without tone
and gradation. I do not suggest that the sky is never
one even tone all over, but in that state it is seldom of
much use to the artist, and it *is* tone—not white paper.

Fig. 5.

A plain blue sky, without cloud, is perfectly gradated
from the deep blue of the zenith down to the pale
horizon.

The sky is the one thing that gives expression to
nature. It would be a monotonous world without the
smiles and frowns of the sky. The artistic possibilities
of the clouds are infinite. It is the most valuable
element to the photographer; it is the one department
of nature which lends itself to the landscape artist, and
he neglects it. With a properly selected sky he can

alter his composition, and rule his chiaroscuro. In short, it is one of the most potent elements to aid him in rescuing his art from the machine.

Given the necessity for a sky, then science inter-feres. The photographer is usually deluded into endeavouring to discover some method of taking the sky with the landscape, and almost certainly gets into a semi-scientific state of mind which takes more pleasure in conquering a useless chemical difficulty than in

Fig. 6

obtaining a splendid effect with ease that would give pleasure to the world. Experiment for experiment's sake is the enchanted forest in which many who possibly may have grown up into good photographers get mazed and lost.

There are, of course, occasions when it would be advantageous to secure the sky with the landscape on one plate, but they depend upon as many *ifs* as Touch-stone's. *If* the lines of the sky compose well with the foreground ; *if* some other arrangement would not be

conducive to pictorial effect; *if* the sky will come as strong as it is in nature; *if* it can be got without sacrificing the landscape, and a great many other "ifs," then the sky would be better taken on the same plate as the ground, but not otherwise.

Every landscape photographer who would represent nature truly should make a collection of sky negatives for future use, always noting the time of day and of the year, the direction and altitude of the sun, and the aspects of nature at the time each sky negative is taken. Every variety of effect should be secured, and the attention should not be entirely confined to the grandest effects.

I have given my own short and simple method of taking skies above, but to save those who may be tempted out of the straight path towards art by technical diversions, I will give a full and complete formula for taking skies, requiring no modification whatever, and so plain and clear that it should prevent even the weakest photographer from having any frivolous thoughts towards chemical discovery.

Any slow plates, isochromatic preferred.

Shutter exposure.

Pyro and ammonia developer. Formula to be found on any packet of plates.

Patience in developing.

The result should be clean, thin negatives, nearly clear in the cloud shadows.

The method of using a sky negative is so well known as to scarcely bear repetition. When a print is taken, the place where the sky ought to be will be white, or if it prints grey the space may be stopped out with black varnish on the back of the plate. Now take a suitable cloud negative, place it in the printing frame, and adjust the print on it so that the sky shall print in

its proper place. When exposed to the light the landscape portion should be covered with a black cloth or other suitable mask. Success depends on the care and skill by which any effect of the join is hidden and truth to nature observed.

There should not be a bit of plain white space any where about a photograph, except, perhaps, in minute quantity, such as in a figure. There is no such thing in nature. Even in a woody scene, where

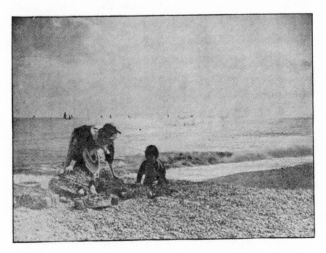

Fig. 7.

very little sky shows through the trees, as in fig. 2, the treatment of the sky makes all the difference between a good picture and an ordinary photograph. It will be noticed in this illustration that the strength of the clouds is very slight, but the various gradations harmonise the different forms and help to concentrate the light. A plain white sky would have *grinned* through the trees. To make the picture complete there ought to be a picturesque figure on the path.

Although there may be only a small portion of sky peeping through a corner it would not be wise to neglect it. Fig. 3 is an example of this. If the sky had been left blank the light and shade and composition would have tumbled to pieces. The same may be said of fig. 4, where the sky and figures make a picture out of very simple materials.

Fig. 5 is an example in which the sky forms an important part of the composition. Repetition of a light or form, but not of the same strength as the principal, is a useful device in art. In this case the sky was selected because the general effect of the clouds echoed the forms of the sheep. I know that this is sometimes called conventional, or fancy composition, but I also know that it produces a pleasing effect on the ordinary spectator without their knowing exactly how it is done.

Fig. 6 shows how breadth may be attained by a judicious use of clouds, also how a picture may be made out of scarcely any materials at all. Fig. 7 is an example of an extension of the use of combination printing, which, perhaps, takes it out of the region of the clouds, for it includes the sea on the same plate as the sky, with the figures and foreground on another plate.

In order to show that this attention to the sky is not a new " fad " I select old pictures as illustrations.

I should add that if the student cares to make the photographing of the sky of real interest he will study the nature and forms of the clouds.

CHAPTER XVI.

THE SEA.

LOVE of the sea is the heritage of every man of English descent, and knowledge of it in all its wonderful effects grows yearly more and more among all classes. Each year the sea takes increasing hold of our painters, and pictures of it cover more space on the walls of our exhibition galleries, but their is still room for the great photographer who would make the sea his own; there is still room for photographs in which we can feel the sensation of the power and glory of the ocean, the salt spray, the gloom, the brilliancy and the infinite movement.

We have lost our greatest sea painter in Henry Moore, R.A. No painter ever represented the sea so faithfully, and yet made his picture look less like a coloured photograph, than Moore. His work was the highest impressionism without the least touch of the eccentricity and affectation that so marred the work of the impressionists of a few years ago, but which is now disappearing. One reason why he gave us the spirit of the sea so faithfully was that he always painted straight from nature, and never asked photography to help him. He had every temptation to make use of our art. In the early days of photography he experimented extensively. For forty years he was my intimate friend, and took the greatest interest in photography; yet he never used our art for pictorial purposes; he took a higher view of photography than using it as a hand-maid would imply. He looked upon photography in its higher phases, as a kindred art to painting, not as a mere

servant or assistant of the painter, and took the greatest interest in our Salon, speaking at length in our discussions on art subjects held during the exhibition season. I have mentioned him here because his pictures seem to me to be of the kind we should aim to produce, simple pictures, in which incident is not the chief purpose, but giving the absolute expression of the sea in its many phases.

As a rule photographers are more deficient in those qualities which are derived from impressionism than almost any other, and true impressionism should receive a good deal of the attention of the studious photographer. There are many subjects in which the incidents consist of little more than the harmonies presented to us by certain effects. They are to be found, perhaps, more plentifully at sea than anywhere, and one great recommendation of impressions derived from the sea is that they are not yet hackneyed, neither, indeed, are they within the reach of every photographer, but it happens to some of us. It is my good fortune to be invited to take part in an annual cruise in a large steam yacht, and perhaps a description of some of the photographic incidents in one of our cruises, that of 1895 for instance, with a few of the results of my hand camera, may be of interest and possibly instructive.

All yachtsmen have heard of the Clyde fortnight. During this period the great regattas of the Clyde take place. The racing in 1895 was unusually interesting on account of the trials of the grand new yacht, *Valkyrie III.*, which was built to take part in that unfortunate contest for the American Cup, which ended in a wrangle. The races proved that there were really too many excitable people in the world, and not enough water space near America for a fair yacht race—and for pleasure steamers at the same time.

I was fortunate to get close to the three great
yachts when they were so grouped that they came on
one plate. These great competitors raced together
throughout the season. They were Mr. A. B. Walker's
Ailsa, Lord Dunraven's *Valkyrie III.*, and the Prince of
Wales' *Britannia*.

During the Regatta we were part of the time at
Hunter's Quay, in Holy Loch, and spent some days
" potting " everything deemed worthy of a plate among

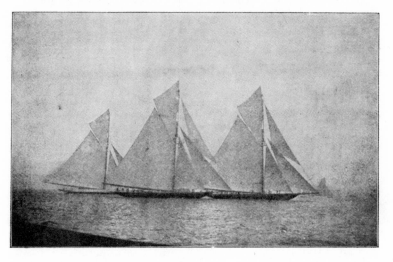

(₁) VALKYRIE III. AILSA. BRITANNIA.

that great gathering of yachts. Photographing vessels
going at a rapid pace is not the simple and artless matter
it seems to be; there is always room for a good deal of con-
sideration as to the precise moment when to let go the
shutter. The relation of the direction in which the
vessel is going to your standpoint has much to do with
the length of exposure that can be afforded. A moving
object coming towards or going away from you covers
the same piece of background or sky for a much longer
time than does an object passing you. Some knowledge

of the object to be photographed is always of use to the photographer. In photographing a yacht it adds to the facilities if you can form a reasonable forecast of her motions during the time she is within view ; the handling of her sails and whether she is likely to tack. Tacking is a good instance. As a vessel goes about, her sails often assume picturesque forms, but for so short a time that it is necessary to be ready for them before they occur. This can only be done by the photographer having a sufficient knowledge of sailing. There is also

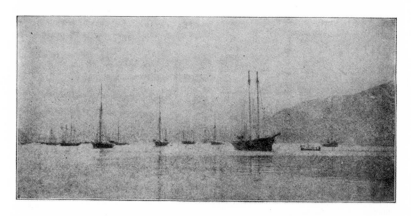

2 HOLY LOCH.

much that is useful to learn from a study of the motions of waves and birds.

The little sketch (2) will give some idea of the peaceful effect in Holy Loch as night closed in. The schooner with her topmasts struck is the *Selène*, tender to *Valkyrie III.*. Many of the crew of the racer pass the night on her. A boat, crowded with her men, may be seen going on board. One of the most magnificent pleasure boats present this year hailed from New York. Mr. Howard Gould's steamer, *Atlanta*, is shown in the next illustration (3).

Some of the most attractive subjects to be obtained
during a cruise by those who can see them are effects of
light and shade, sunbeams and passing storms. Here
is a slight description of what I mean. After the Regatta
we started to go round the Mull of Cantyre, and up the
West Coast to Oban. The wind was strong all the
morning, with rain squalls. When we had reached the

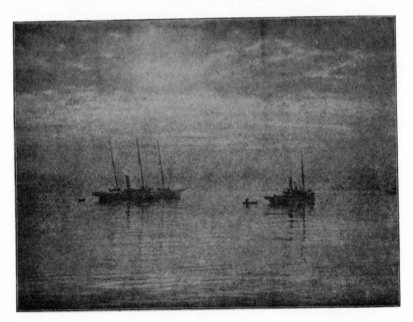

(3) ATLANTA.

more exposed part of the Firth, off the Pladda light, it
came on to blow what sailors call a whole living gale,
which I heard afterwards was the most severe summer
gale known for many years. Four or five of us were
spending the time in the deck cabin which afforded us a
view of the sea nearly all round. It was raining and
getting ominously dark, when one of us jumped up
shouting, " What is the matter with the sea ? " Towards

the horizon was a vast, white, dancing streak, cause at first unknown though soon apparent. The sky above was black, the broad streak of white boiling water came rapidly towards us, and we were suddenly smothered in a deluge of hail and rain which came down solid and made the yacht stagger. Then we were glad ours was a steam yacht, and, giving up rounding the Mull, which no vessel accomplished that night, we ran for shelter to

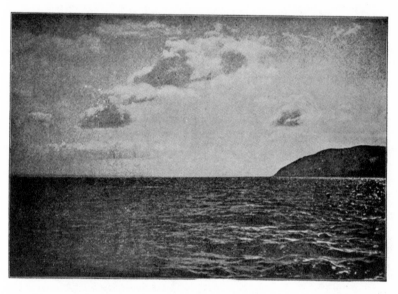

(4) SEA AND SKY

Campbeltown, where many exciting events occurred in the gale, and I succeeded in obtaining effective shots at a couple of small yachts that had broken from their moorings with no one on board, and were feared by the big yachts, and chased by adventurous small boats for the sake of salvage.

Of course I did not get a snap at that wonderful phenomenon; it came too suddenly and I had not foreseen the possibility of anything happening worth photographing

during such weather. But it would have been possible, and the mystic effects of the black sky, and the brilliant white of the wall of the sea churned up by the rain and hail, would have made a picture—that nobody would understand, and almost everybody would call eccentric!

Besides yachts which are graceful and beautiful, there are some more common objects of the sea not so beautiful, but more picturesque. I mean the old sailing

(₅) ON BOARD.

ships, barges, colliers and fishing boats, as well as those trading steamers that give off vast volumes of smoke which take fantastic forms and often add greatly to pictorial effect. These are best sought for at the mouths of great rivers. As I have said above, what I should like to see studied at present are the effects of sky and sea. No. 4 is an example of what I mean. Seagulls are by no means difficult to secure, and I have many negatives of them. Nor is all this chance work. The

I

first illustration to the last chapter is an example. Some of my negatives contain hundreds of gulls, but numbers do not always add to the effect.

Groups on board are often interesting, not that I give the final illustration as an interesting one. It shows part of the deck of the *Heatherbell*, on which some few photographers may recognise the present writer enjoying one of the happiest moments of his life.

CHAPTER XVII.

RURAL SUBJECTS.

𝕿HERE is so much good material for pictures in the rural districts, besides pure landscape, at various periods of the year that it may be of use to the student to be reminded of some of them, and of the seasons at which they occur.

The weather in January and February is generally so unexpected that it is difficult to know what to call attention to in the way of subjects. At the time of year at which I am writing a few years ago we had just got to the end of a terrible nine weeks of frost and snow. This season, at the same time—January 21st—we have been almost entirely without frost. However, as I have given a chapter to winter photography we may go on to March.

March is said to come in like a lion and go out like a lamb; but that was in the time of the poets. Our modern Marches are apt to be a bit blusterous throughout. Yet it is a delightful if not a gracious time. March awakens sensations perhaps more delicious than the other two following months, for it gives us the first taste of spring, and the feeling that the fine weather is all before us. The sap rises, in a manner of speaking, in all nature, and the air is so pure and fresh that it makes us delighted to feel that our enemies, the malignant microbes, have possibly to wear respirators to save themselves from being poisoned by the health-giving ozone.

The early flowers, generally of a more delicate and poetic beauty than those of any other time, are beginning

to peep in gardens, woods and fields. Many of the best
known and best beloved of the wild flowers are with us
this month. We know them best; they are the friends
of our youth, a time which we perhaps best remember.
The snowdrop we had last month; the gorse is always
in blossom (or kissing would go out of season), and is
now approaching its greatest golden but prickly per-
fection; the kingcup and the daisy are early comers;
the modest silver stars of the wood anemone, with their
outer tints of delicate mauve, attract children to the
woods, to make pictures for us; then there are arums
(better known as cuckoo-pint, or lords and ladies); and
the glossy leaves and burnished flowers of the lesser
celandine or pilewort.

> " The first gilt thing
> That wears the trembling pearls of spring."

This flower should be of interest to the scientific photo-
graher, for it is a combined actinometer, thermometer
and barometer, being one of the most sensitive flowers
to changes of light, heat and atmosphere.

The violet is now more plentiful than ever, chiefly,
more is the pity, in the flower-girls' basket, a manu-
factured article; it is disappearing from the hedgebanks
in the neighbourhood of towns, but later the dog-violet
is to be found in profusion on commons, often accom-
panied by purple orchids. The primrose is following
the fate of the violet, and is disappearing from the
woods and hedges, although it is largely cultivated and
forced for sale in hot-beds. Nature is giving way to
machinery even among the common flowers.

Then there are daffodils in favoured localities;
daffodils that "take the winds of March with beauty."
A favourite flower with Shakespeare who sings in that
wonderfully breezy song in the " Winter's Tale":

"When daffodils begin to peer,
With, hey! the doxy over the dale—
Why then comes in the sweet o' the year."

This, however, is digressing from the subject for which
I began this chapter, although it is much allied to it.
Natural History is always useful to the artist.

A little anecdote occurs to me that may put me in
order.

Years ago, at a water-colour exhibition, there was an
exquisite little picture of a fight between two birds, a
robin and a fly-catcher, for a worm on a path of trodden
snow. At the private view, the artists were in raptures
about it, the painting was so free, so natural, so true.
But a naturalist who knew something about birds asked
what a fly-catcher wanted with a worm, as it was not
his usual food, and why the bird was in England when
the snow was on the ground, seeing that he migrates
to warmer climes until April or May, and what business
had the worm on the surface of the snow-bound earth?
This rather knocked the sawdust out of the doll, until
one boldly asserted that they were looking at the picture
as artists, not as naturalists, and the presence of inac-
curacies did not destroy the art; and that to add a few
markings, and slightly alter the colour of the fly-catcher,
changing him into a sparrow, who eats worms when
very hard pushed for food, and will always gladly
fight any bird of twice his age and weight, and rejoices
in winter, would add nothing to the art, although it may
to fact.

This necessity for facts in art is a tough question,
which never ceases to be discussed, but we won't go
into it here, for it is certain that the circumscribed
limits of the photographer will preserve him from any
serious mistakes. It is not, therefore, to save him from
errors he ought instinctively to avoid that I would have

him study the "birds, beasts, and flowers—and fleas," but that such study would give him an insight into Nature and teach him to observe; for observation, the power of *seeing*, is the first and greatest faculty of the true artist. All the rest comes almost mechanically. The study of Nature adds a "more precious seeing to the eye," and makes the ear more quick of apprehension. And the man is to be pitied

> " Who never caught a noontide dream
> From murmurs of a running stream."

Drawing, photography, and other methods of art are only means of expression; feeling and truth are the spirit of a work of art, and can only come by exercise of the art of seeing.

It has always been a favourite notion of mine that, if an artist is not something more than an artist, he must be a bad artist, or, to mangle Shakespeare, the man who has no love of nature in his soul is only fit for mechanical photography. It is my good fortune to know many artists who adorn other arts besides the photographic, and all take an intelligent interest in Nature apart from their own speciality, and some are deeply learned in the natural sciences, but not to the exclusion of their own art, as too often happens with us. Entomology, botany, ornithology, and geology are the chief studies, and one is far gone in infusoria and paleolithic flints, and all are fishermen to a man. The contemplative man's recreation is the one amusement that leads us nearer to nature. Izaak Walton went fishing and caught fish, but, as has been finely said by a writer in a late number of the *Field*, " While fishing he was all eye and all ear; and thus his fishing was but a small part of his pleasure. The river bank was to him at once a picture gallery and a concert room, ever instructing him, ever delighting him." And so it should

be with a photographer. Other sports that take us into the country, I am afraid, give us little time or opportunity for looking around us. Even our own special subject, photography, although it takes us into the woods and fields, does not induce us to go into the minutiæ of Nature as thoroughly as sketching and fishing do. In painting the details have to be looked into and studied, and in the other delightful art the the flyfisher is bound to acquire some knowledge of natural history and the weather.

The subjects for March are numerous. Primrose gatherers are often to be met with, and bird-nesting towards the end of the month. The hedge sparrow's, with its four sea-green eggs, is the first nest of the season. Angling, cattle feeding, ploughing and sowing are now being carried on. The lambs are beginning to appear; hedging is nearly over; timber felling is still going on, so also is plantation thinning and the cutting of coppice wood, and there is work being done in the osier beds.

April affords many subjects for the camera. In the early part of the month the budding trees, especially the birch, are very beautiful. Feeding cattle in the yards still continues. Clearing stones from fields, bush harrowing, and many subjects of last month are carried into this. Sowing used to be a favourite subject with our painters, but machinery has now supplanted the broad-cast operation. Angling is in full swing, and gives picturesque motives for figures. Blossoming fruit trees are pictorial, but little used; and the sea and sky at this time of year are usually full of beauty.

The months of May and June teem with subjects for the photographer. Rural occupations affording food for the camera are so numerous and conspicious as to. require little pointing out, but attention may be

called to tree barking, osier peeling, and cowslip gathering. Subjects containing sheep should be photographed before the end of May, when shearing begins, after which the sheep may be cooler, but they look naked, and have not the usual supposed beauty of the nude.

The same may be said of July, and not much description will be necessary. Some subjects such as flower gathering and fishing, occur through many months of the year, and will not require repeating. During June and July some rural occupations occasion a good deal of picturesque smoke in the fields, which, under skilful treatment, ought to afford motives for good pictures. Now is the time that the husbandman has his annual fight with weeds, and he cremates his enemy in many a bonfire. Late sheep-washing and shearing are now going on. These favourite subjects of the painter have never been done complete justice to by the photographer. Haymaking, most picturesque of rural subjects, is about early in July, and in some seasons late in June. Peat and turf cutting subjects are to be found on moors and heaths; bird-boys watch the corn crops; there is much gathering of heath-berries and mushrooms. Cattle now seek shade and water—in short, the country is full of incident and beauty. The wonder is that photographers should be so full of moderation as to let so much escape them.

Autumn! Harvest! and the voice of the reaping machine is loud in the land. With the use of machinery much of what was picturesque to us in agricultural pursuits has departed. Perhaps to another generation the reaping machine, discarded for something still more useful and ugly, will be as picturesque as the sickle of the reaper of the last generation, or the scythe in the hand of old Father Time is to us. Nevertheless,

there is still much that is beautiful to be picked up in
the cornfield. As to hops I must confess that delight-
ful as a hop garden is I never have been able to find
a picture in hop-picking. Now is the time to make
moonlit pictures; pictures by real moonlight, not the
usual frauds printed in blue-green, with a wafer to
represent the Queen of Night which are sometimes
palmed off on an ignorant public as the genuine
article. The harvest moon of August and the hunter's
moon of September, give the best light of the year
from that source. Seed-time affords good foregrounds ;
I have seen a lovely subject consisting solely of a bank
of seeding thistles, with a glimpse of stream and distance
beyond. The margins of brooks and dykes now dis-
play a luxuriance of wild flowers, and the water-lilies
are at their best. Water-flags, bulrushes, and reeds
have attained their full growth, and make good motives.

Has any photographer ever tried to produce a
child-picture suggested by the "Fairy Rings," those
well-defined and bright green circles to be found in
the autumn on downs and commons? Until we grew
wise they were attributed to lightning or the fairies.
Now we know it is the spreading growth of a fungus.

> "Do not all charms fly
> At the mere touch of cold philosophy."

Now also in late summer, and through the fall of
the year come the holidays through which many plates
are exposed, and many successful photographs taken
and some few pictures secured.

But the chief business and enjoyment of the time,
and quite rightly, is securing records of our travels
that we may be reminded in the future of past delights,
for half the enjoyment of a holiday lies in the pleasures
of memory. The holiday soon passes, but memory is
more, lasting. As Hood says of giving a party, "Part

of the pleasure of having a rout is the pleasure of
having it over." The pleasures of memory are enor-
mously increased if to your mental picture-gallery you
can add a gallery of truthful aids to memory. We
don't want the counterfeit presentment of the hotel
where we spent an uncomfortable night; the pier on
which we landed; the lodgings we hired in a row; or
even the little Bethel we visited; we want well-
executed views of the beauties of nature. I particularly
want a picture of cloud-capped Arran in sunlight after
a thunderstorn, and of that sunrise at Gourock, which
seemed to set the world in a blaze. Then tourists
want photographs of the glories of architecture, quaint
costumes and varying customs of the lands through
which they pass. Sitting at home in winter, such pictures,
with maps and even time-tables, would help to waft
the memory through many delights—climb again many a
mountain, sail again over many a summer sea, hear
the ripple and feel the breeze. Memory, like the sun-
dial, need mark no hours but the bright ones. But
this in my case would be a useless provision. I have
never known an hour on a yacht that was not a
bright one. Even the sea-demon that sometimes
seizes luckless mortals for his own is more easily
endured on a yacht than on a crowded Channel
steamer.

CHAPTER XVIII.

LESSONS FROM BIRKET FOSTER.

BOOK illustration has now become so common, and, unfortunately, much of it is so bad, that it must be striking indeed to claim more than a passing glance. Still there is good work done, swallowed, as good photography has been, by the enormous output of inferior

JANUARY

work. Notwithstanding, however, the great attention paid to this branch of art by skilful artists, I cannot call to mind any illustrations of the day that equal, for the purpose for which they were intended, the work of those fathers of the art—Sir John Gilbert and Birket Foster— in the past. These two great and popular artists kept up a constant supply of illustrations for very many years— over fifty—and have had many imitators, but no equals.

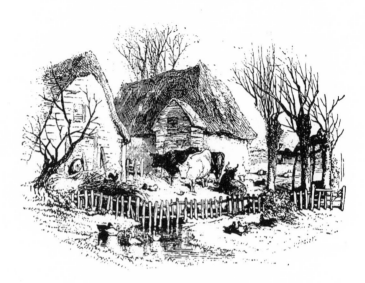

FEBRUARY

MARCH

APRIL

MAY

Mr. Foster's drawings have been especially worthy of
the study of the photographer, his genre and landscape
subjects being of the kind very possible in photography.
They are always well composed on simple and well
defined lines, but with great art, visible to the expert
but not obtrusive to the general reader.

I have secured a dozen of this artist's early blocks,
representing the months, which will enable the student
to clearly see what a very simple and effective thing good

JUNE

composition is, and yet how various may be the effects
with scarcely any variation of a few and simple prin-
ciples. For it must be recollected that although Birket
Foster improved in his work on the wood, and became a
famous painter, he never changed his principles of
composition, which must have run through many thou-
sands of examples.

The arrangement of all these little pictures is based
on a few of the simplest rules of composition as taught

JULY

AUGUST

before difficult and bewildering subtleties were introduced. These include balance, contrast and emphasis, variety, breadth, repetition, unity and harmony, with diagonal lines and masses formed by them, and graceful curves.

As a typical example we will take " February." In looking at it what is the first object to catch the eye ? The group of cows. This begins the interest of the picture and is therefore *emphasised* by the black and white cows being strongly *contrasted*, being composed of

SEPTEMBER

the highest light and darkest dark used. This device is *repeated*, but in a less degree, in the group of black and white ducks which *balance* the angle of the principal pyramid. This is a method the artist constantly employed. Compare, for instance " June," the contrast of the two horses repeated in the ducks in the foreground. To return to " February." Diagonal lines run in every direction forming pyramidal masses all united. All this is so happily put together as to appear (as it should to the casual observer), to be done without thought, yet it

OCTOBER

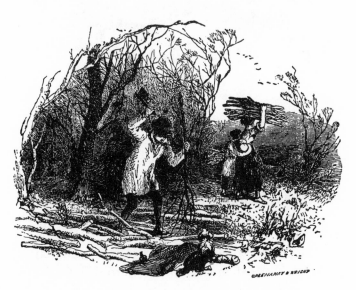

NOVEMBER

K

looks like nature, as well as pictorial, not in spite of, but because it was done on a settled plan. The effect comes " by art not chance."

The irregular diagonal line, running from the left top corner, down the roof of the barn, over the cows, to the right hand bottom corner, is not an accident, neither is the pyramid formed by the group of cows as the apex and supported by the ducks and cocks and hens, or the

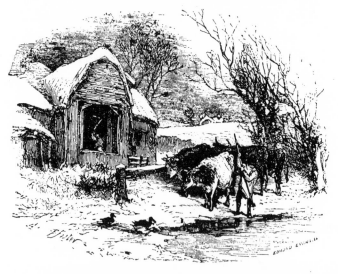

DECEMBER

contrast of the diagonal tree on the left with the stiff upright pollard willows on the right. All these things are intended to be felt more than seen. The student will also notice in many of these sketches that the artist takes every opportunity of enclosing his picture with graceful lines. This is oftener possible in photography in the foreground (see group of cows, "July"). The strong emphasis of small quantities of contrasted black and white has another very useful function. The strong

opposition of the extremes of light and dark puts tone into the rest of the picture and makes it more atmospheric.

To one who has studied formal composition there is not a touch in this "February" that does not aid the composition, yet there is nothing that catches the eye as formal. The result is great variety but "not without a plan."

A curious variation is to be found in "April," which the artist seems to have made an exercise in the principle of repetition. Repetition is used to check variety running to excess, and was much used by the Dutch masters. It is also one of the principal elements of repose in Art. We have here two pairs of trees, two pairs of men, one pair of oars, one pair of uprights, and one of horizontals in the bridge, with diagonal general forms, forming a series of wedge This is perhaps a bit fanciful, and not possible to the photographer, but if he will study and compare these designs in the light of the words I have written, he will find a liberal pictorial education in these beautiful little pictures.

CHAPTER XIX.

WINTER PHOTOGRAPHY.

SPRING, summer, autumn, we have travelled with the year from month to month, and now winter, the oldest of the seasons, is upon us. In the spring, the artist who is able to select his days may, with impunity, work out of doors for several hours at a stretch, and enjoy that lovliest of all seasons and the re-birth of nature. In the summer and autumn, however, he finds that his outdoor work gives the greatest amount of pleasure, for he can do it in physical ease. From May's gentle smiles until the coming of the rude blasts of the autumnal Equinox, nothing interferes with the comfort in which he works, except rain and an occasional summer gale, however much he may be hindered by variation of effects and the travellings of the sun ; for, when the earnest student buries himself in his work, time often gallops, as Touchstone says it does with a thief to the gallows, and lights and shades alter all too quickly. Then comes winter and we feel the " season's difference," but the photographer is better off, and the painter, planted with the easel out in the dreary winter landscape, looks as miserable and out-of-place as draggletailed garden chrysanthemums in the November rains ; both he and they have ceased to be an ornament to nature.

Still there are enthusiastic painters who, in the pursuit of their profession, are content to brave the fury of the elements, the fear of rheumatism, neuralgia, colds, fevers, and the multitudinous ills to which suffering humanity is subject from fall of temperature and adverse hygro-

metrical condition. Numerous are the devices for making the situation less unbearable and to prevent the hand from stiffening, but nothing enables human nature to endure the misery for long. Thick boots and a slab of cork may save the feet from slush or snow; heavy coats, ulsters, rugs, furs, may protect the body; but all fail to greatly prolong the agony. Portable stoves have been tried, but roasting one side of the body does not prevent the other side from freezing; when

> " Sheath'd is the river as it glideth by,
> Frost-pearl'd all the boughs in forest old,"

the landscape painter finds his work almost impossible. " Providence tempers the wind to the shorn lamb " says Sterne, a sentiment so beautiful that many take it for scripture, but the shorn lambs of art have not yet devised any effective method of defending themselves from the blasts of winter, and nothing is left except manful endurance, which after all is delivering Art into the hands of those who are physically the stronger.

Yet it is possible that photography is the providence that will temper the wind to them.

It is from the causes just indicated that no great winter picture has ever yet been painted. For I think it must be conceded that the representations of wintry scenes have never equalled those of summer nature in any age of art. I cannot call to mind at present any adequate rendering of snow. There is, of course, Gérôme's " Duel," but the snow painting does not rise above the quality of figure painter's landscape. In the exhibitions a few winter subjects are almost always shown. These are sometimes perfect as far as they go, but they seldom go beyond an impressionist's imperfect rendering of snow. The pathetic wretchedness of the world in winter is suggested, but it is a memory, not a study. Then again there is Turner's " Frosty Morning "

in the National Gallery, perhaps the truest rendering of
a black frost ever painted.

What we so seldom see on the walls of an exhibition
is any carefully studied representation of the more
elaborate detail of wintry nature—all the varieties of
frost, black frost, white frost, hoar frost. Hoar frost,
that dream of beauty, when the frozen dew on the boughs
sparkles with the radiance of jewels, and weaves arches,
bowers and festoons, creating an arctic fairyland; and
snow, through its endless variety of effects from the time
the first thinly dancing minute flakes come down, then
larger and more abundant, until the whole air is dark
with them, and the earth becomes a white and silent
world, a world full of fresh subjects for the artist if he
could paint them, and certainly for the photographer
when at his best. The snow ceases, and sometimes
come skies as blue as the petals of a forget-me-not;
the nipping and eager air tosses the frozen powder in
whirling masses of fine spray; the snow in the roads
gets broken up into picturesque raggedness by passing
waggons with their long teams of horses, and gives
opportunity for foregrounds full of strength and detail.
Then note, in some effects of light when the sun is low,
the lovely irridescence of the snow and the startling
contrasts of the rosy lights and cobalt shadows. The
congealed rivers only show themselves by their wintry
hues, with abrupt patches of black here and there. The
mill is clothed in its white shroud, and "icicles hang by
the wall;" the woods in the weak sunligh are lovely;
the intricate tracery of the trees difficult to draw; the
oak alone retains some of its autumn leaves of tawny gold
colour repeated, however, by the dead bracken, and con-
trasted by the dark green leaves of the bramble, which
never dies. The sportsman crunches the frozen mass as
he looks for pheasant, hare, snipe, woodcock, or wild-

duck. Then on the open fields those winter visitors from the north, the redwings, thrushes and fieldfares are picking up a precarious existence.

Besides what may be suggested by the above, there are many subjects for winter work connected with the farm, although the march of machinery has banished a good deal of the picturesque farm country life, and we do not now enjoy—and suffer from—the severe winters of years ago. Cattle and sheep congregate in the farm-yard, or are fed in the open with hay and corn and turnips; the wonderful intelligence and vigilance of the well-trained collie can be studied in the extra care required in looking after sheep, especially in the mountainous districts during snow, and even the robin demands attention, and can be studied by the Christmas card and illustrated number artist.

It may be said that winter as a subject for the painter or photographer is played out, that the Christmas number has killed it, and that we do not now get the winter of the poet and the imaginative artist. This is quite true. It is a positive fact that winters are not what they were. Few of us can recollect such winters as those described—to take one book at random—in "White's Natural History of Selbourne," or like the winter of 1837 when the smoking ruins of the burnt-out Royal Exchange appeared in the morning covered with icicles, like the transformation scene of a pantomime. This mildness may be due to the increase of population, and consequently increased number of fires in houses and manufactories, as well as the greater warmth of the surface of the land from draining and disforesting. However that may be our winters are less cold than those of our forefathers. This year the winter is un-usually late in putting in its first indication. As I write in the middle of January, we have had no frost; the low

sun is shining brilliantly, but with a golden splendour ; there are blossoming primroses and snowdrops ; a thrush in a neighbouring tree is in full song.

It must be conceded then, to return to our theme, that winter offers a great number of good subjects for the artist, and that the almost insuperable difficulties to the painter in the way of studying the infinite detail of wintry nature out of doors has little effect on the photographer.

In conclusion I have a word to the amateur photographer who makes photographs for no other purpose than to show how beautiful they are. You almost always pack away your apparatus at the end of autumn. It is the fashion, I suppose, or you may be tired after the hard work you have done during the summer, but you little know the beauty that you lose. Attune your mind and look out for the beauty of winter, and you will find it, even in a thaw and " February fill dyke." The only special piece of apparatus I can recommend to the photographer for this work is a strong pair of boots.

CHAPTER XX.

INDIVIDUALITY.

IN a recent number of *Blackwood's Magazine* an ingenious writer tries to show that the one thing more than another that now represents primitive man is the baby, and that the nineteenth century British baby differs very little from the savage child of, let us say, a couple of hundred thousand years ago, for the baby is nearly a quadruped, and is a reckless creature devoid of conscience. It is, perhaps, a knowledge of the fact that babies are all alike that enables photographers, as it is libellously said, to make the negative of one of the species satisfy the yearnings of many mothers. Now, photography is certainly somewhat like this view of the human race in the respect that its immature productions are all alike, and it is not until they grow up and acquire a conscience or soul that they differentiate and show individuality.

Of the immature there is no end, but a wise and invariable provision of nature checks over-production. Nature is always wise, but has no mercy ;

> " So careful of the type she seems,
> So careless of the single life ; "

and, seeing that the world would be overwhelmed by immature photographs, sent beneficent fading to destroy them (always, as in other departments of nature, " so careful of the type," sparing a few) until the art grew old enough to possess a soul or conscience, and then permanent methods were given to us ; and even now we sometimes feel inclined to paraphrase the wisdom of Mr. Whistler, and say modern photographs do not fade, and

therein lies their deep damnation. This wonderful preservation of a few in all their pristine freshness is suggestive of a special providence, for according to the scientists, who are, of course, always right, like methods should produce like results, and not one of the old prints should have escaped.

Now, evidence of soul or conscience in a picture is art. Yet there are those who will not recognise that we have a soul, but, like Mr. Gilbert's mechanical figures in the *Mountebanks*, are only stuffed full of badly made machinery that sometimes runs down, and always moves with a jerk ; and I am not sure we are not suspected of trying to adopt the " put a penny in the slot " business to the fine arts.

It is a favourite reproach with the opponents of photography as a picture maker that its results are all alike ; it is one of the triumphant proofs of those who will not admit that photography is an art that the un-thinking machine makes all its products to the same pattern ; that there is no intrinsic evidence in any photo-graph of its maker. They will no more believe the plainest evidence to the contrary than those of old would believe the angels. They say we are mechanical, and it is of no use pointing out that this wild assertion is obviously untrue, we hear it over and over again, some-times from one who knows that it is not true, at others from those who are simply ignorant and cannot learn. These are to be pitied. Then, there are those whose purpose it serves to deny ; and, worst of all, those who have tried, and altered their faith because they failed, those who, as the poet says, " fade away, and dying damn." To the credit of photographers there have been very few of these.

It has no effect on the prejudiced critic to point out, that if different minds using the same machines produced

like results invariably, as machines are expected to do,
any one of them who understood the machine ought to
be able to turn out a series of masterpieces equal to the
best that have ever been produced, always providing, of
course, that one machine was as good, and as well brass-
bound and French-polished as the other. Yet they
continue to say—and this is one of the latest utterances
of science: "The picture painted by the artist is a
transcript of his own emotions, but a photograph is not
a reflex of human emotions at all—unless, indeed,
accidentally so—but is a direct reproduction of nature,
and only through science the offspring of man." We
must be grateful to the writer for allowing us the accident.

I am quite ready to confess that up to a certain
point, and in the hands of the ninety per cent. of the
followers of the art who are not artists, the photograph
is in the process; but with the others the picture is in
the man (as in painting, only in a less degree, and as far
as the materials will allow). The process takes a very
subordinate place, and is dominated by the taste, thought,
and feeling of the artist, when an artist uses it with
what may be fairly called emotional results. Who has
not laughed with many of Rejlander's characteristic
heads, or wept—yes, I have seen even that emotional
result produced by a photograph (which was not an
accident), and it is an important part of my argument
that all these emotions arose first in the mind of the
photographer, and would never have been originated by
the same models in the hands of another photographer.

Of all the attempts made to prove that photography
was not an art, that which would have most force, if
proved, would be that it showed no evidence of
individuality; but, on the other hand, if the possession
of that quality were proved, it would be one of the
strongest arguments in favour of the admission of

photography to the brotherhood of art, for individuality, in its products, necessarily implies the operation of a directing mind behind the " soulless camera."

The latest of the many attempts to define the meaning of the word " art " is a very remarkable one. It is said to be, " The apparent disproportion between the means employed and the end obtained." And, as an illustration, the following explanation is given, at which, I think, many a practical photographer will smile.

" Admit, for argument's sake, that a photograph reproduces with a fidelity far beyond anything that the hand of man can attain to, it must still be allowed that the means used to attain this end are infinitely more complicated than the few hairs tied to a stick which the artist uses. Indeed, it might be argued that, if *art* is the apparent disproportion between means and end, photography is not art at all, but science. There is no art on the part of the lens when it produces its images ; it does so strictly in accordance with natural laws. The developer acts as thoughtlessly as any other chemical experiment, and these are the chief factors in every photograph. It is true, you have one small part to play —you must have the *art* of exposing properly ; but even here a few shillings will purchase for you a machine to do even this. I do not admit art in development. Art in development is only called in when the exposure has been made without art, and, as I have already allowed art in exposure, I cannot allow it here again. With such an infinitesimal part of the picture the outcome of art, is it honest to call a photograph a work of art ?" Are we to understand from this singular piece of reasoning that painting is an art because the painter uses "a few hairs tied to a stick ?" and does the writer suppose that we claim photography as an art because of its fidelity—that heritage of the youngest amateur ?

Some writers get confused between degree and kind. In an article in the *Magazine of Art*, a certain writer, who was once a photographer, endeavours to show that photography cannot become art, because its individuality is limited. That it is more limited than painting has always been admitted—we cannot get so far away from the truth as is the painter's privilege—but it is also admitted that all methods of art are more or less limited, and the amount of limitation is only a matter of degree, not of kind. The limitations add to the difficulty, but do not alter the status.

Let us run back a little and see if we can find a few workers whose results are totally different from those of their contemporaries, and this invariably. One of the earliest photographers to show genuine art feeling in his work was Rejlander. He died sixteen or seventeen years ago; yet, among many thousands of photographs, it does not require much experience to recognise a Rejlander. There was nothing in the manipulation to distinguish them, except, perhaps, carelessness. It was the mind of the man that was visible, you recognise the man beyond the process. There are still those living who can say, on looking at a collection of old photographs, This is a Francis Bedford, a Dr. Diamond, a Fenton, a Delamotte, a Le Gray or Silvy, a Wingfield or a Mrs. Cameron, certainly quite as accurately as an expert in painting would say this is a Raphael, or Titian, or a Correggio. Then, what becomes of the machine argument?

I will now endeavour to put it another way. Photographs, as I have endeavoured to prove, show the mind of the producer—when he has a mind to show—and given two equally gifted photographers, as far as equality can be measured, the one could not produce even a colourable imitation of the work of the other. Neither

could dismiss his individuality let him try how he may. Take two representative men, Rejlander and Bedford, neither of these accomplished photographers could have imitated the other. They had both original minds, and followed the bent of their genius, and their hands, as well as brains, showed in every picture.

Among the workers of the present day, I could point to dozens of well-known instances, but one or two must suffice. No man's work has been more imitated than that of Col. Gale. In every exhibition, he is imitated in size, style, framing and signature, yet an expert can decisively say of two pictures, This is the Gale, and this the imitation; he can even distinguish between the imitators, and say, This is a——, and this a——.

We now come to another proof of individuality. It used to be the practice to insist on anonimity at exhibitions until after the judges had done their work: but this was given up when it became apparent that the judges usually recognised the work of the old hands, and the only nameless ones were new exhibitors. In America —at least at the Convention Exhibition—the farce of the anonymous is still carried to such an extent that nobody seems to know, officially or otherwise, who the pictures are by until it is too late to be of any use to the exhibitors; and newspaper criticism has to be published without names. For, however the photographs may proclaim their authors, it seems to be etiquette to pretend not to know.

The difference between the works of some of our best photographers and those of the moderately successful can scarcely be due to a scientific cause, except, indeed, to a reversal of the generally received idea; for I think, if the truth were known, it would be found that the producers of the indifferent pictures had much more

scientific knowledge than those who produce the most artistic pictures. I am acquainted with a great many of our photographers, but I do not know one of those to whom we are accustomed to look for the chief ornaments of our exhibitions, who have any elaborate scientific knowledge. Indeed, their technical methods are so very simple as to seem quite elementary They usually take a plate to the make of which they are accustomed, a simple pyro and ammonia developer, a handful of hypo, and a jug of water, and use them properly ; and that is all. They do not bring science to bear even on the exposure, at the expense of "a few shillings." They get on without an actinometer. They feel from experience when their plate has had enough, and an actinometer, however perfect, would only confuse them. But, as they endeavour to put taste, thought, and feeling into their pictures, their works necessarily differ from those of the scientist, and the essence of their art is individuality.

My last word here must be a word of caution. Be original, be unique if you can, but not out of harmony. Individuality goes wrong when it is out of harmony with its surroundings. Eccentricity is very easy, but it does not last. It is open to the meanest capacity, and is often assumed by it ; but genius, to be useful, should consist of individuality, backed up by suitability to its environments.

L

CHAPTER XXI.

CONCLUSION.

AND so we come to the end. Let us have a few words by way of farewell, in general reference to what has been written.

It would be a paradox, I suppose, to say that the art is so easy that it is exceedingly difficult; but I cannot help attributing much of our mediocrity to our extraordinary facilities. I become more convinced every day that the cause of so little good work being done, and the swamping of that little by so much bad, is the constant clearing away from the processes of those blessings in disguise—difficulties.

It is only in Paradise that roses grow without thorns and the evidence on this curious horticultural point is not without suspicion; but on earth we would not give up the perfume of the rose because of the prickles. Difficulties, rightly appreciated, are the salt of art. Adverse criticism, which is a stumbling block to some, should be a stimulus to exertion, and exertion leads to success. Shakespeare tells us: "There is some soul of goodness in things evil, would men observingly distil it out." And so we may go on multiplying platitudes on the subject by the ell, or, as Touchstone offers to rhyme, "eight years together, dinners, and suppers, and sleeping hours excepted," for it is a question on which most thinkers are agreed.

Photography would be better if its elements were not so easily comprehended as to make it almost a frivolous pursuit, and to cause it to be included with

amusements and recreations. It is generally admitted that the dwindling of difficulties in ordinary technique since the introduction of gelatine plates has not been an unmixed good. Difficulties may sometimes perplex and overpower; but when ease in any pursuit comes in, endeavour flags and emulation ceases.

In the days of calotype and collodion, when difficulties bristled at every step, there was but one photographer where there are now a hundred, or perhaps, a thousand; but that one was an enthusiast, and the average of those who attained the excellence of the time was much higher than it is now, when ordinary technical difficulties are smoothed away. In the days of difficulties the exhibitions were as well filled as regards quantity, and in some respect as regards quality, as they are now. Some exhibitors may have been more conspicuous than others, but nearly all the exhibits had some special interest; but at the present time (except, perhaps, in the Salon), after the works of some half-dozen exhibitors have been seen, the rest—better in mechanical technique than the old pictures—have no particular features and attract only languid interest. Why is this? Because they have no character and individuality. In this age of irresponsible and thoughtless criticism, timid men are afraid to be original; but the few deviations from sanity have more real interest than the most hot-pressed perfection of the machinist's art. Not that I am an admirer of outrages on any art. The ease of the process now levels nearly all, as far as they go, to a dead level of soulless perfection. I say "as far as they go" advisedly, for few get beyond that point where the perfection of manipulation ends, and stop short where the use of ideas begins, where the true technique of art is required, and where a knowledge of

pictorial effect and how to get it is absolutely necessary to further progress.

All this, as I have said, comes about by ease of process. When the acquiring of the means of art is difficult, the time required for learning the processes gives opportunity for absorbing, almost unconsciously, the principles of the art of which the rudiments are being painfully learnt. The student of music learns something about music as well as the means of managing the instrument; the student of art cannot fail, during his years of drawing and modelling, to learn something of the *spirit* of the art of which he is a student. It is different with the present-day photographer. A little serious attention soon teaches him all it is necessary to know to enable him to produce a perfect technical negative and print, and there usually his artistic education ends, or perhaps it would be truer to say it never began. But easy success in acquiring ordinary technique, so that he may produce something that he knows is technically good, but has not knowledge enough to know is artistically worthless, beguiles him from the path that would probably make him an artistic photographer, to follow the delusion of making technical discoveries, and lose himself in chemical and optical subtleties.

The extraordinary craving for anything but the spirit of the art in photographers reminds me of a little story.

Jedediah Buxton was a prodigious calculator of the last century. He was once taken to the theatre to see Garrick, and he was seen to pay great attention to the play. When he was asked how he had been impressed by the acting, Jedediah replied by giving the number of words and syllables that Garrick had spoken. His mind had been occupied solely by this mechanical

M

operation. The grandeur of King Lear had escaped him.

I don't want to make too light of the preliminary technical difficulties of photography, and for some reasons should like to keep up the old notion of the awe-inspiring mysteries and intricacies of ordinary technique if it did any good or led to anything, but to concentrate the attention on the supposed difficulties of a very simple thing does absolute mischief, and I cannot help " blowing " on the farce.

The real struggle begins after the student is capable of producing good technical work. It is here that he should recognise where the merit of the materials ends and the power of art begins. That this is not known is proved by results as shown in the exhibitions. Enough of processes for all practical work being known, let the photographer learn how to put his skill to the best use. The study of art will be found an absorbing pursuit, and not easily followed if the mind is being continually irritated by vexatious variations and distracting details.

Some will ask, How is the education of the photographer to be conducted after it reaches the perfect negative point ? It is not easy to say, but this is certain, photography, for pictorial purposes, must no longer be considered as a science. It must be treated merely as a means of producing pictures, just as are pencils and brushes. It must be treated as a means of expression ; the photographer must learn how to see and feel ; he must study how others have seen and felt, and the means they have taken to show what they saw and what they felt about it, not for the purpose of appropriating their thoughts, but that the contemplation of their works should induce thought in themselves, and then he may hope to give expression to himself with the tools of his adopted art.

It may be questioned if all are capable of learning ; certainly not all in the same degree, or with so much ease as they would master a definite mechanical pursuit. There is another still more serious question, because applicable to the case of so many amateurs. May those who cared not for these things in their youth take to them, as so many try to do, in middle age ? Readers of Dickens will remember that a feeling of profound melancholy came over Mr. Richard Swiveller when he discovered that the Marchioness had passed her youthful days in ignorance of the taste of beer. How many photographers are there who want to make pictures who had no taste for art in their youth ? But these latter need not despair. It really will not take very exacting study to rise far superior to the ordinary mechanical photographer, and add pleasure to the pursuit. Many find when they begin to study that their talent existed, but was only latent, waiting to be developed.

After some time passed in studying—and even imitating—the works of others, I would recommend the student to endeavour to be original, and to remember that originality should *not* be undiscovered plagiarism. This is the most fruitful method of getting into delightful difficulties I know. Let him for a time be deaf to echoes, and shout for himself. He will make many mistakes ; he may even become eccentric, and the aggravation of eccentricity is that it is seldom original ; but if he takes the lesson rightly, he will first become humble, then hopeful, and afterwards confident, and if he is faithful and persistent he may " arrive."

THE LITERATURE OF PHOTOGRAPHY

An Arno Press Collection

Anderson, A. J. **The Artistic Side of Photography in Theory and Practice.** London, 1910

Anderson, Paul L. **The Fine Art of Photography.** Philadelphia and London, 1919

Beck, Otto Walter. **Art Principles in Portrait Photography.** New York, 1907

Bingham, Robert J. **Photogenic Manipulation.** Part I, 9th edition; Part II, 5th edition. London, 1852

Bisbee, A. **The History and Practice of Daguerreotype.** Dayton, Ohio, 1853

Boord, W. Arthur, editor. **Sun Artists** (Original Series). Nos. I-VIII. London, 1891

Burbank, W. H. **Photographic Printing Methods.** 3rd edition. New York, 1891

Burgess, N. G. **The Photograph Manual.** 8th edition. New York, 1863

Coates, James. **Photographing the Invisible.** Chicago and London, 1911

The Collodion Process and the Ferrotype: Three Accounts, 1854-1872. New York, 1973

Croucher, J. H. and Gustave Le Gray. **Plain Directions for Obtaining Photographic Pictures.** Parts I, II, & III. Philadelphia, 1853

The Daguerreotype Process: Three Treatises, 1840-1849. New York, 1973

Delamotte, Philip H. **The Practice of Photography.** 2nd edition. London, 1855

Draper, John William. **Scientific Memoirs.** London, 1878

Emerson, Peter Henry. **Naturalistic Photography for Students of the Art.** 1st edition. London, 1889

*Emerson, Peter Henry. **Naturalistic Photography for Students of the Art.** 3rd edition. *Including* The Death of Naturalistic Photography, London, 1891. New York, 1899

Fenton, Roger. **Roger Fenton, Photographer of the Crimean War.** With an Essay on his Life and Work by Helmut and Alison Gernsheim. London, 1954

Fouque, Victor. **The Truth Concerning the Invention of Photography:** Nicéphore Niépce—His Life, Letters and Works. Translated by Edward Epstean from the original French edition, Paris, 1867. New York, 1935

Fraprie, Frank R. and Walter E. Woodbury. **Photographic Amusements Including Tricks and Unusual or Novel Effects Obtainable with the Camera.** 10th edition. Boston, 1931

Gillies, John Wallace. **Principles of Pictorial Photography.** New York, 1923

Gower, H. D., L. Stanley Jast, & W. W. Topley. **The Camera As Historian.** London, 1916

Guest, Antony. **Art and the Camera.** London, 1907

Harrison, W. Jerome. **A History of Photography Written As a Practical Guide and an Introduction to Its Latest Developments.** New York, 1887

Hartmann, Sadakichi (Sidney Allan). **Composition in Portraiture.** New York, 1909

Hartmann, Sadakichi (Sidney Allan). **Landscape and Figure Composition.** New York, 1910

Hepworth, T. C. **Evening Work for Amateur Photographers.** London, 1890

*Hicks, Wilson. **Words and Pictures.** New York, 1952

Hill, Levi L. and W. McCartey, Jr. **A Treatise on Daguerreotype.** Parts I, II, III, & IV. Lexington, N.Y., 1850

Humphrey, S. D. **American Hand Book of the Daguerreotype.** 5th edition. New York, 1858

Hunt, Robert. **A Manual of Photography.** 3rd edition. London, 1853

Hunt, Robert. **Researches on Light.** London, 1844

Jones, Bernard E., editor. **Cassell's Cyclopaedia of Photography.**
London, 1911

Lerebours, N. P. **A Treatise on Photography.** London, 1843

Litchfield, R. B. **Tom Wedgwood, The First Photographer.**
London, 1903

Maclean, Hector. **Photography for Artists.** London, 1896

Martin, Paul. **Victorian Snapshots.** London, 1939

Mortensen, William. **Monsters and Madonnas.**
San Francisco, 1936

*Nonsilver Printing Processes: Four Selections, 1886-1927.**
New York, 1973

Ourdan, J. P. **The Art of Retouching by Burrows & Colton.**
Revised by the author. 1st American edition. New York, 1880

Potonniée, Georges. **The History of the Discovery of
Photography.** New York, 1936

Price, [William] Lake. **A Manual of Photographic Manipulation.**
2nd edition. London, 1868

Pritchard, H. Baden. **About Photography and Photographers.**
New York, 1883

Pritchard, H. Baden. **The Photographic Studios of Europe.**
London, 1882

Robinson, H[enry] P[each] and Capt. [W. de W.] Abney.
The Art and Practice of Silver Printing. The American edition.
New York, 1881

Robinson, H[enry] P[each]. **The Elements of a Pictorial
Photograph.** Bradford, 1898

Robinson, H[enry] P[each]. **Letters on Landscape Photography.**
New York, 1888

Robinson, H[enry] P[each]. **Picture-Making by Photography.**
5th edition. London, 1897

Robinson, H[enry] P[each]. **The Studio, and What to Do in It.**
London, 1891

Rodgers, H. J. **Twenty-three Years under a Sky-light,** or Life and
Experiences of a Photographer. Hartford, Conn., 1872

Roh, Franz and Jan Tschichold, editors. **Foto-auge, Oeil et
Photo, Photo-eye.** 76 Photos of the Period. Stuttgart, Ger.,
1929

Ryder, James F. **Voigtländer and I:** In Pursuit of Shadow Catching. Cleveland, 1902

Society for Promoting Christian Knowledge. **The Wonders of Light and Shadow.** London, 1851

Sparling, W. **Theory and Practice of the Photographic Art.** London, 1856

Tissandier, Gaston. **A History and Handbook of Photography.** Edited by J. Thomson. 2nd edition. London, 1878

University of Pennsylvania. **Animal Locomotion. The Muybridge Work at the University of Pennsylvania.** Philadelphia, 1888

Vitray, Laura, John Mills, Jr., and Roscoe Ellard. **Pictorial Journalism.** New York and London, 1939

Vogel, Hermann. **The Chemistry of Light and Photography.** New York, 1875

Wall, A. H. **Artistic Landscape Photography.** London, [1896]

Wall, Alfred H. **A Manual of Artistic Colouring, As Applied to Photographs.** London, 1861

Werge, John. **The Evolution of Photography.** London, 1890

Wilson, Edward L. **The American Carbon Manual.** New York, 1868

Wilson, Edward L. **Wilson's Photographics.** New York, 1881

All of the books in the collection are clothbound. An asterisk indicates that the book is also available paperbound.